Calligraphy

Margaret Daubney

The Art of Crafts

First published in 2000 by
The Crowood Press Ltd
Ramsbury, Marlborough
Wiltshire SN8 2HR

British Library Cataloguing-in-Publication Data

A catalogue record for this book is available from the British Library.

ISBN 1 86126 230 2

Dedication
For John.

Acknowledgements
The photographs of the lettering on Trajan's Column (page 45) and of Bembo's son-
nets in Italian (pages 59 and 60) are reproduced by kind permission of the Board of
Trustees of the Victoria and Albert Museum, London.

The photographs of MS Harley 2904 (the Ramsey Psalter) on pages 35 and 36 are
reproduced by permission of the Trustees of the British Library.

The photographs of MS The St Cuthbert Gospel on pages 76 and 78 are repro-
duced by kind permission of the British Province of the Society of Jesus (photo-
graph by courtesy of the Trustees of the British Library).

Photography by Richard Kolker.

Typefaces used: Melior (*main text and headings*); Helvetica (*captions*).

Typeset and designed by D & N Publishing
Membury Business Park, Lambourn Woodlands
Hungerford, Berkshire.

Printed and bound by Leo Paper Products, China.

Contents

Introduction

This is a practical book. It is a book which will inform, guide, help and, I hope, encourage and inspire you. If you are a beginner, you will find all the information you need about basic equipment, what to buy, how to use it, what letterforms to study, how to practise and how to use your new skills. All the little problems and pitfalls which I can think of and which you might encounter are explained. If you are a more experienced calligrapher, some of your continuing difficulties and uncertainties – such as I can't get this nib to work, I'm unsure about using colour, how do I begin to plan a design – will be answered, and there are plenty of suggestions to help you to improve your work and to move on to the next stage.

To get the best out of this book:

◆ Do take time to read the text. It is very tempting to turn straight to the diagrams and try to copy them, but you will find mastering calligraphy easier and quicker if you understand what you are doing.

◆ The explanations of the principles underlying each script are probably more important than the diagrams themselves. Written letters are not made by machines so inevitably they are not absolutely uniform. While this gives them strength, vitality and character, it also means that you will tend to pick up my idiosyncrasies if you simply copy without understanding.

◆ Calligraphy is beautiful writing and writing is language made visible.

Although it is necessary to begin by making careful studies of individual letters, we should never lose sight of our eventual aim which is to put letters together to make words, to express ideas and thoughts. So as soon as you dare, use your calligraphy to write words and make things. It takes very little experience to write 'Happy Birthday' inside a card.

◆ Do not expect it to be easy. Formal writing is a precise skill taking practice to acquire a polished expertise.

◆ Regular practice is important and making things is the best practice possible.

◆ Be brave. Too many people feel that they are not 'creative' because they believe that the creative craftsman simply sits down one morning and produces a wonderfully inventive piece of work. Not true. Creativity is about thinking, doodling, hard work and putting a lot into the waste-paper basket. If you have an idea, try it. No one need see the mess you make, but you could learn a lot from it, and you may surprise yourself.

◆ Finally, enjoy yourself. Enjoy the shapes of letters, the colours and textures on the page, the sensual pleasure of the nib on good paper. Enjoy the words you are writing. Above all, enjoy the satisfaction of completing a piece of work to the best of your ability.

1 Tools and Materials

The essentials for any calligrapher are a writing surface, a writing implement, a writing fluid and something to write. Today, most calligraphers following the formal Western tradition work on paper using ink or paint applied with a square-cut steel nib fitted into a pen holder.

The basic equipment is easy to obtain and inexpensive. You may have already used a calligraphy fountain pen or felt tip. These are both available with square-cut calligraphy nibs or tips. They are easy to use and perfectly adequate for certain purposes, although they do have their limitations. Felt tips become soft quite quickly and the marks they make will not be crisp. Also, the range of colours is small and lacks subtlety, a limitation shared with fountain pens which use ink cartridges. You may find as well that the rather narrow range of nib sizes offered by some manufacturers is inhibiting your work.

If you are a complete beginner, a fountain pen with a square-cut nib will give you no problems of ink flow or control, and it may be a useful way to begin your formal letter studies, but it will not help you to learn about touch, about rhythmic movement, or about quality of line, all of which must form part of your calligraphic understanding.

When I work with inexperienced students we use dip pens and bottled ink from the beginning. However, if you join a class you may well find that your tutor begins in a completely different way.

This is neither right or wrong, it is simply different. It is important to understand that there is no single right way of doing things, but that whatever tools you choose to use will affect the character and the quality of the work you make.

WHAT TO BUY

This is your essential shopping list:

- pen holders

- a set of round hand nibs with separate or attached reservoirs

- black non-waterproof ink

- A3 layout pad

- a drawing board

- pencils
 (HB, H or B, well-sharpened)

- a soft eraser

- a 45cm (18in) ruler

- a selection of gouache paints

- mixing dishes and inexpensive brushes

- left-handed nibs, cut at an angle, are available for left-handed calligraphers.

Dip Pens

A dip pen which you assemble yourself is a simple, unrefined instrument compared with the sophisticated modern fountain pen, but that is its strength. A fountain pen is a specialist tool, made to be as easy as possible to handle, but it is designed for a narrow range of tasks. A dip pen is harder to manage at first, but when you've tried it, you will find it infinitely more versatile and flexible than its specialist cousin.

Learning to use a dip pen will also help you to appreciate that formal calligraphy is not just another kind of handwriting. It is a quite different skill, involving a different kind of thinking and movement, and it has a quite different purpose. I believe that using a tool that is at first unfamiliar helps the mind to dissociate this activity from everyday writing and to adjust to the idea of making something much more disciplined, aesthetic, satisfying and important.

To begin, you will need pen holders, a range of round hand nibs and reservoirs.

Pen holders are available in a variety of shapes and sizes. Some are long, some shorter, some have faceted sides, others are rounded. Choose the one which feels comfortable in your hand and buy several. If you are willing to pay a little

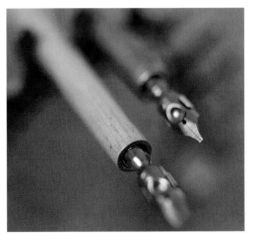

more you may find hand-turned wooden holders, which are very pleasant in the hand, at craft fairs or markets.

The nibs which are most easily obtainable, Rexel or Mitchell nibs, are available in a range of ten sizes. Make sure that they are square cut. If you are left-handed, you will probably find left oblique-cut nibs easier to use. It will be assumed throughout this book that you are using Rexel or Mitchell nibs and reservoirs.

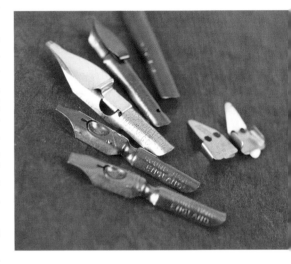

You will need a number of reservoirs. These clip onto the underside of the nib, creating a space in which to hold the ink or paint. You may also be able to buy nibs with an integral reservoir which sits on top of the nib. These are very good quality and some calligraphers prefer to use them, but different nibs need different touches. You will find out with experience what feels best for you.

Ink

Bottled black non-waterproof Indian ink is the easiest and most convenient ink to buy and to use. You must be careful not to buy waterproof Indian ink because the shellac in it will clog your nib quite quickly, holding back the ink flow. It

will also make the nib difficult to clean.

On the other hand, fountain pen ink is too thin to be useful. It flows quickly, making it difficult to control, and it does not cover the paper evenly.

Commercial calligraphy inks vary in quality from manufacturer to manufacturer and sometimes from batch to batch. Some are too thick and 'bleed' into the paper, giving furry lines; try diluting these inks with a few drops of water. Liquid Chinese and Japanese inks are usually of good quality, although they may need further dilution or be rather sticky.

The best solution is undoubtedly to make your own ink, for which you will need an ink stick, an ink stone and a few drops of water. If your local art shop cannot help, try a specialist Chinese or Japanese shop.

Paper

Layout paper is thin, has been treated with size so that your letters do not spread when you write on it, is inexpensive and readily available. A paper which has been sized has had a film added to

the surface of the paper which prevents it from absorbing ink. Some good quality papers have the sizing added to the paper pulp during the manufacturing process so that the surface of the paper is not completely smooth and has some texture. You will need an A3 pad of paper for your first trials and exercises.

A Drawing Board

A drawing board provides a firm, angled surface on which to write. A commercially made board is an unnecessary and probably unwise investment at this stage. Wait until you are more experienced and know how to choose one that suits both your needs and work space.

Begin by using a piece of plywood, or something similar, and sand down any rough edges. Your board should be at least A2 (594mm × 420mm), it must be rigid and not warped, heavy enough to be stable yet light enough to be balanced on your knees comfortably and rested against the edge of a table.

Pencils

You will need several medium hardness pencils, such as HB, H or B. Pencils must be long enough to balance in your hand and must be very well sharpened. Use a pencil sharpener or a craft knife regularly to maintain a good point. Do not make do with elderly stumps of pencils – buy some new ones.

Ruler

Your ruler should be long enough to be useful – at least 45cm (18in). You might find it worth investing in a metal ruler or a plastic one with a metal edge against which it is safe to cut.

Eraser

Choose a good quality eraser which feels soft, and keep it clean.

Gouache Paints

To write in colour, use gouache paint diluted with a few drops of water and mixed to a consistency which flows easily in a dip pen. The written line will be opaque and you will have the freedom to mix an infinite range of colour variations.

OTHER USEFUL EQUIPMENT:

◆ large, sharp scissors

◆ craft knife with disposable blades

◆ cutting mat and straight edge

◆ glue stick

◆ masking tape

◆ PVA glue

◆ dividers, pair of compasses, protractor, T-square

Watercolour paints and liquid acrylics can also be used in a pen, but bottled coloured inks are often too thin to be used for formal writing.

Mixing Dishes

You will need some small mixing palettes in plastic or porcelain in which to dilute and mix your gouache paints.

Brushes

These are for mixing paint and for feeding ink or paint from the bottle or dish into the nib, so they need not be expensive painting-quality brushes. The cheaper, man-made fibre brushes serve the purpose admirably; about size 4 is useful. Keep one for your black ink and others for your colours.

The equipment in the list below will serve various purposes.

Cutting

Scissors are useful for cutting up drafts, but finished work should always be

◆ old toothbrush

◆ Arkansas stone or crocus cloth.

The purpose of the Arkansas stone or crocus cloth is to sharpen and care for your nibs. Arkansas stone is very hard and fine-grained, but quite difficult to buy. It will also be very expensive. A top-quality hardware store may be able to help. Crocus cloth is a very fine-grain abrasive paper which you will probably find among sewing and embroidery materials.

trimmed with a knife which gives a cleaner line. Craft knives are inexpensive, comfortable to use and have disposable and interchangeable blades.

A self-healing cutting mat is an expensive investment, but it will keep the blades of your knife sharper for longer and the grid makes cutting much easier.

A straight edge is a heavy steel rule with no calibrations that is used for cutting against. A plastic ruler with a metal edge is a safe alternative.

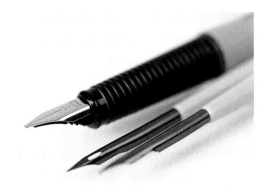

Sticking

A glue stick is useful for drafts and roughs. Masking tape should be low tack and repositionable. PVA glue is a strong white glue suitable for permanent finished pieces of work.

Measuring

Dividers, compasses, protractor and a T-square will all be useful when ruling up or making detailed letter studies.

Maintenance

The life of a nib can often be prolonged by gentle sharpening on an Arkansas stone or on crocus cloth.

An old toothbrush is invaluable for cleaning nibs and reservoirs after use.

You may also wish to experiment with other equipment:

◆ automatic pens, multiple-line pens

◆ mapping pens

◆ square-cut brushes

◆ masking fluid

◆ a variety of papers.

There is a huge range of tools, materials, inks and paints available for you to try. Those listed here are likely to be the most useful for your calligraphic work.

A VARIETY OF PAPERS

Layout paper is the calligrapher's basic 'rough' paper, useful for exercises, first drafts and for roughing out ideas. It is important to buy at least an A3 pad because you will need room to move and to see what is happening as your work develops. A smaller sheet will restrict your writing and your ideas and will be less comfortable to work on.

Fine handmade and mould-made papers.

Handmade Asian papers.

Layout paper is machine-made, one of three different manufacturing processes by which paper is made.

Machine-made papers are made in enormous continuous rolls and then cut to size. The majority of papers are made this way. They often have a significant acidity and therefore are not of archival quality, but they are usually inexpensive. They are good for practising on and are often suitable for finished work.

Mould-made papers are made as individual sheets on a cylinder mould machine. They are often made from cotton fibres, are of archival quality and will cost more than machine-made papers. You are likely to find them among the watercolour papers in your local art shop.

Handmade papers are, as the name suggests, made in individual sheets by craftsmen. This makes the papers more expensive but it also means that each sheet will have its own personality. Refined and elegant handmade papers are just as useful to the calligrapher as the more robust papers made in India, Thailand, Nepal and other parts of Asia which are now available, but you must be prepared to try out a paper and to find and learn its character.

Weight

This helps to identify the thickness of a paper. Most layout paper is 45gsm – each sheet weighs 45 grams per square metre. The higher the gsm number, the heavier, and therefore usually thicker, the paper. Everyday photocopier paper is usually 80gsm, a light watercolour paper is about 180gsm and a heavier watercolour paper at 300gsm is beginning to feel quite stiff.

Surface

Good quality paper usually comes in one of three surface finishes:

♦ A hot pressed (HP) paper has been dried and then pressed through rollers. Pressure and heat are both applied to give a smooth surface. This is the surface which most calligraphers prefer.

♦ A NOT paper has been lightly pressed and has a slightly textured surface. It is so called because it is not hot pressed. You may find it referred to as 'cold pressed'. This is suitable for some calligraphic work.

♦ A rough paper has not been pressed and so will have a textured surface which is difficult to work on with a pen.

The texture of a NOT or rough paper will be more evident on the heavier weight sheets.

Most papers are sized during the manufacturing process to prevent ink from spreading when the paper is written on. Sometimes the crispness of your writing will be improved if you use a dusting of gum sandarac. This is a resin which is usually bought as granules. Grind them to a fine powder using a pestle and mortar – the powder will have a distinctive, rather pleasant smell. Cut a square of silk, place the fine powder in the centre and gather the corners over it to make a tight little bundle. Secure with a rubber band and tap the bag of sandarac over your sheet of paper. The fine powder will escape through the close weave of the silk and onto the surface of the paper. Blow away any surplus powder. The sandarac is water repellent and will help to give you cleaner lines of writing.

A pad of paper sometimes gives a pleasing range of coloured papers.

Grain Direction

All machine and mould-made paper has a grain. This becomes important if you need to fold your paper to make a card or a book. Take a full sheet of paper and lay it on a flat surface. Lift one short edge, bring it over and lay it on top of the other short edge. Hold the two edges down flat with one hand, letting the middle of the sheet curve loosely. With your other hand feel the 'bounce' in the curve. You will probably feel quite a bit of resistance. Now lay the sheet flat and do exactly the same thing but taking long edge to long edge; again feel the resistance. Which ever 'bounce' is weaker and gives you less resistance becomes the crease in your paper. With most papers long edge to long edge will be with the grain and will be the easier way to fold the paper. The result will be a clean fold which will lie flat.

Choosing Paper

Many machine-made papers are suitable to write on with ink or paint. You will find a wide range of colours, weights and sheet sizes.

Avoid papers which are very lightweight. Paper of 120–140gsm is suitable for a small book but a larger piece of work will probably need something more substantial.

Do not be tempted by very smooth, shiny paper; your nib will slide and be difficult to control on such a surface. With experience, you will learn which surfaces are slippery and which are good for your touch. It is important to appreciate that your touch is unique; what suits you may well not suit another calligrapher.

Some watercolour papers, made for painting, are very good for writing. Choose an HP surface in one of the lighter weights for your first trials. You may find the heavier weights of watercolour papers – over 250gsm – more difficult to write on because they are rather hard and unforgiving. Printmaking papers, in contrast, may feel a bit soft but many are useful for calligraphy. Some are available in particularly large sizes and some in a range of subtle colours.

It is important to remember that the paper is an integral part of the work that you are making and so it is necessary to choose with discrimination. As you become more confident, you will learn which papers suit your work and which are pleasant for you to write on.

The following are some points to bear in mind when choosing paper:

◆ Always try writing on both sides of the sheet when you try a new paper to see which is easier for you to work on.

◆ Buy paper in large sheets rather than in pads. This both makes economic sense and gives you more flexibility as your work progresses.

◆ Store your paper flat if you possibly can, or loosely rolled with the grain.

◆ Always handle paper with clean hands and great care. Cracks or crumples will spoil the appearance of your work. The best way to pick up a piece of paper is by holding the diagonally opposite corners.

◆ Remember that you will need to 'rehearse' on your chosen paper before you complete your finished piece, so make sure that you buy enough paper to complete the task.

◆ Be prepared to buy single sheets of different papers so that you can try each one and make an informed choice. Keep a folder of samples with notes – the name of the paper, where you bought it, the price, how easy or difficult you found it to write on.

◆ Browse in art shops, compare notes with your friends, never be afraid to try something new.

QUILLS AND VELLUM

The usual writing tool and writing surface of the mediaeval scribe working on an important manuscript are still available and in use today. A few contemporary calligraphers work exclusively with quills, others use them occasionally, some not at all. The same is true of vellum and parchment. A quill is strong, flexible and responsive, but it takes time and practice to learn to prepare it adequately. The right feathers from the right bird – goose, swan and turkey are usually good – must be

The same piece of work was completed on both vellum and paper.

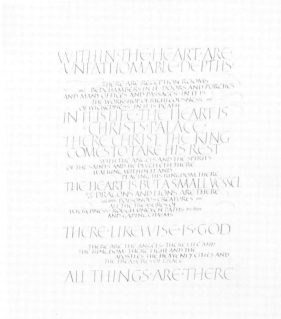

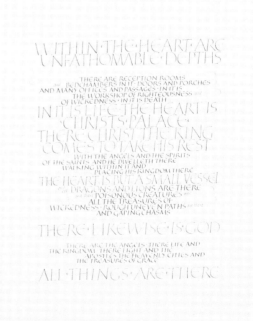

chosen with care and then prepared, cured and cut with skill and understanding. Once in use, a quill requires constant attention to keep it in good order. It will become blunt particularly quickly if used on certain harder papers.

Vellum and parchment are animal skins prepared for writing; vellum is usually calf skin and parchment usually sheep. Both give a beautiful writing surface and have the advantage of longevity. Both are expensive to buy and you will need to give a skin further preparation to create a really good working surface. If you are making a piece of work which is larger than very small – say about 15cm (6in) square – the vellum will probably need to be stretched around board to prevent it from moving with atmospheric variations.

Learning the skills to prepare and work with traditional tools and materials are crafts in their own right. By all means try them if you have the opportunity but I would not recommend them to beginners.

For the contemporary calligrapher, vellum may sometimes be the perfect surface but for many pieces of work it would be inappropriate. It is important always to choose the most appropriate tools and materials for the context in which they are being used.

SETTING UP YOUR WORKPLACE

Where you choose to work will obviously be governed by practical considerations, but it is worth making your space as comfortable as possible if you are to produce your best work while avoiding tired eyes and the aches and creaks to which calligraphers can be prey.

The ideal workspace is a good area of flat table on which, or against which, your drawing board can be angled. This gives you room beside your board for your inks, paints and other equipment.

Good light is essential. Work in daylight if you can, with the light source to your left if you are right-handed and to your right if you are left-handed. Northern light is the clearest, most even light because you will not be troubled by the movement of the sun. When you need artificial light, use a repositionable lamp, preferably with a daylight bulb, so that you can direct the light to exactly where you need it. Do not try to work in poor light; not only will your eyes feel tired but your work will suffer and you will probably be disappointed with your efforts when you look at them in clear light.

Preparing Your Drawing Board

Whether you are using a commercially made board or a simple piece of wood, the surface needs to be properly prepared before you can use it for writing. While the board provides a rigid support for your work, the surface must be cushioned so that there is a response to the pressure of your nib. Any paper can be used for this, but the sheets must be large enough to cover the board surface and there must be enough to make a pad. Large sheets of blotting paper, cartridge paper or newsprint are ideal.

Lay the pad of papers on your board and tape firmly round the edges with masking tape. This pad now stays permanently taped to your board. When the top sheet becomes marked, either replace it or simply tape another clean sheet on top of it. The paper on which you are working will then lie on top of this pad. It should not be taped down because you will need to move it as you write.

If you write with your hand directly touching your work, the paper will pick up grease from your skin and the surface of the paper will soon become spoiled. To

protect your work, you can simply place a folded piece of layout paper between the work and your hand. You can then move this protective sheet as necessary.

Alternatively, many calligraphers prefer to tape a guard sheet to the drawing board. You will need a strip of thin paper, such as layout paper, which is as wide as your board and approximately one third of the depth of your board. Line the long edge of the strip of paper up against the bottom edge of the board and tape down just the two short sides to the sides of the board, making a kind of bottomless pocket. Your work then slips into the pocket so that the line on which you are writing shows just above the guard sheet. Your hand will rest on the guard as you write and you can move the work up the board as necessary. The guard sheet is then easily replaced as it becomes creased or marked.

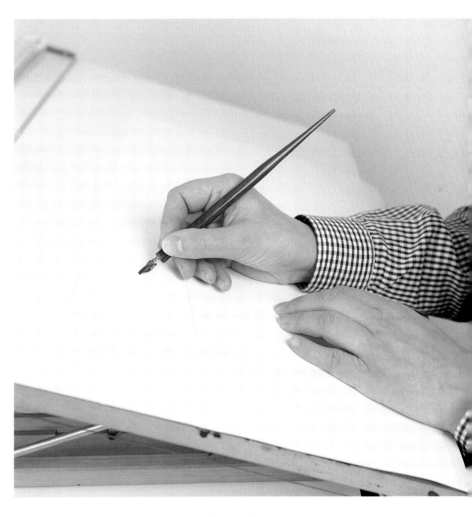

Positioning the Board

A drawing board is used to provide an angled surface on which to write. If you write with a dip pen on a flat table, the ink will flow too quickly. Writing on an angled surface will help you to control the ink so that you can work at a steady pace, making crisp, firm marks. The angled surface also gives you as direct and clear a view of your work as is possible without your having to lean over the paper, risking tension aches and pains in your back and shoulders.

If your board has a hinged base, it stands on the table and should be pulled forward to the edge so that you can sit comfortably upright to work. If you are using a piece of board, it can be angled on the table top if you put a block under the far side of the board so that it slopes towards you. Or, more simply, push your chair back from the table edge, support the board on your lap and rest it against the table edge, again creating a slope. If you work this way, you will not have to worry about the height of your chair; however, for other methods, you must make sure that you are sitting at the right height and are balanced and relaxed.

Sitting at Your Board

Writing is not something that you do with one hand; it is something you do with your whole body. Make sure that you sit upright and square to the board with your feet on the floor and your non-writing hand resting lightly on your work. This will enable you to move easily

in a controlled but relaxed manner. A tense, awkward posture will lead to tense, awkward movements and tense, awkward writing. The balance of a good posture will give you freedom of movement and control, and the rhythmic movement of fluid, fluent writing will develop much more quickly.

CARING FOR TOOLS AND MATERIALS

Tools

Taking care of your tools will help ensure long service from them:

- Always wash nibs, reservoirs and brushes carefully when you finish writing for the day. An old toothbrush is invaluable here.

- Dry nibs and reservoirs thoroughly on kitchen towel to avoid them rusting.

- Use pots, such as old jam jars, to store your brushes, pen holders and pencils.

- Store brushes with the hairs upwards and pencils with the points up.

- Keep pencils sharp and throw them away when they have dwindled into stumps.

- Throw brushes away when they begin to shed hairs. A stray hair in your nib may mark or spoil a piece of work.

- Nibs do not last for ever; if one is damaged or strained, throw it away.

Materials

Your materials will also benefit from care during use and storage:

- Cap bottled ink tightly. A bottle of ink will dehydrate once it has been opened. Add a few drops of water when it thickens. Should it eventually become smelly, or thick and sticky, throw it away and buy a new bottle.

- Ink may separate out as it stands in the bottle. Always give the bottle a shake (carefully!) before you open it.

- After using gouache, wipe the tube clean and replace the cap carefully. Store the paint in a cool place, stacking dishes of reusable mixed paint under a cover of cling film to avoid dust contamination.

- Paper bought in sheets rather than in pads should be stored flat if possible and protected from dust. A good place is under the bed. For protection, plastic envelopes, the large packaging bags which the art shop uses to wrap your purchases or an old sheet will be fine. However, it is probably better not to store fine quality paper in brown wrapping paper for a long period as the acid in the brown paper may, in time, mark your fine paper.

- If lack of space demands that you roll paper for storage, always roll the paper with the grain so that the grain runs from top to bottom of the tube.

- When you want to use rolled paper, lay it flat and weight each

end of the sheet. The sheet will relax and uncurl, although it may take a few hours. Don't try to reverse-roll the paper – you are almost sure to damage it.

◆ Handle paper with care. Cracks, scuffs or fingermarks will spoil the paper and spoil your work. Also make sure that the paper is handled carefully in the shop when you buy it.

◆ Keep your workspace and tools as clean and tidy as possible.

◆ Keep your hands clean.

◆ If you know that you are inclined to be a messy worker, wear an overall, an old shirt or an apron.

CARING FOR YOUR WORK

Many of your exercises/experiments/doodles will go into the bin, but you will also want to keep exercises and ideas which will lead on to pieces of work or which might be useful one day. Keep your very first exercises. When you look at them three weeks, or ten years, later you will be impressed by the progress you have made. Large folders or envelopes are useful for storing such work.

Completing a piece of work by framing or mounting or wrapping it is very important.

Framed Work

You can buy simple picture-framing systems quite inexpensively. Use them if they suit your piece of work, but don't cut the margins off a piece of work in order to make it fit into a ready-made frame. You've put a lot of time, energy and effort into your work and it deserves better treatment. Professional picture framing is not necessarily overly expensive. It is worth getting to know your local framer and asking his or her advice.

Work for Other People

A gift or a commission may need to be framed, but often it is a more informal piece or simply a card.

A small piece of work will always look better if it has defined edges. A picture framer will cut a card window mount to your specification. Try a coloured card mount which picks out one of the colours in your piece of work. If you are neat and careful, you can cut your own mounts with a craft knife. Or, more simply, attach your work to a contrasting paper backing so that an edge of the backing shows all round your piece. Trim the backing sheet so that it makes a frame round your work.

Always wrap small pieces of work with care. A gift will look much more special if you fold it carefully in a decorative paper. Thin Japanese papers or coloured tissue are ideal.

Work for Yourself

If you are storing your own work, wrap it in tissue if it is small and keep it away from dust in a drawer or box. Larger pieces of work should be stored flat and protected from dust. It is worth buying large plastic sleeves from the art shop. Interleave your work with sheets of layout paper to stop the colour off-setting onto another piece of work.

Framing is essentially a protection, and unframed paper will become scruffy if handled carelessly. Always handle your work with care, but do look at it sometimes and enjoy it.

2 Beginning to Write

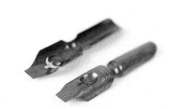

PREPARING THE PEN

The calligrapher's most basic skill is learning to assemble the pen. This will take a little practice at first, but it will soon become second nature and will be easier if you understand just what you are doing and why.

Assembling the Pen

As explained earlier, I am assuming that you are using Rexel/Mitchell nibs with loose reservoirs, as these are the most readily available tools. A new nib has a protective coating from the factory and the ink will flow more easily if this is removed. Hold the nib in a match flame for a few seconds and then wash it or simply plunge it into hot water. Dry it

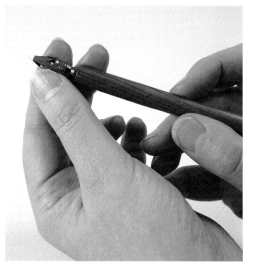

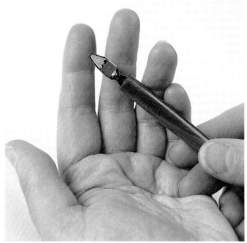

carefully on a rag. (An old linen tea towel makes the best calligraphy rag because it doesn't shed bits of fibre or fluff.)

The pen holder is made up of an outer shell which is hollowed at one end to house a metal spring. The nib should be pushed well down between the metal spring and the outer casing so that it is firmly held in position. If the nib wobbles in the pen holder, you will not be able to control it on the paper.

The reservoir slides onto the underside of the nib, forming a cavity to hold the ink. If the reservoir is too tight to slide onto the nib, ease the two slide flaps with your thumb. The metal is soft and will bend easily. You may also have to bend the tip of the reservoir so that it touches the nib. The relationship between nib and reservoir is quite subtle and it is worth taking the time to get it right.

Remember that the purpose of the reservoir is to hold the ink or paint against the underside of the nib. When you put the nib onto the paper, your pressure eases the tines and the ink flows down the slit and onto the page.

If the side flaps of the reservoir are gripping the nib too tightly, the tines will not ease and the ink flow will be held back. However, if the side flaps are

too loose, the reservoir might fall off. Ideally, the tip of the reservoir should be gently touching the nib, so that the ink does not simply fall out through the gap when you hold the pen to write.

If the reservoir tip is pressing on the nib, the nib will be distorted and you will be able to see light between the tines. Ease the reservoir tip with your thumbnail. The reservoir tip should touch the nib just a little way back from the writing edge of the nib; try a 1mm gap at first. If the tip is too close to the writing edge of the nib, you will feel it catching on the paper. How far back it needs to be positioned depends on the size of the nib, the writing fluid you are using, and your pressure. Generally, a larger nib needs a greater supply of ink and the reservoir should be positioned close to the writing edge. On narrower nibs, it should be pushed further back.

Cleaning the Nib

Nibs, reservoirs and pen holders will have a longer life and will perform better if they are kept clean and rust-free. At the end of the day's writing, separate the nib and reservoir and remove the nib from the pen holder. The nib and reservoir can then be washed in warm water by scrubbing gently with an old toothbrush to remove all traces of ink or paint, and then dried thoroughly on a rag. Avoid getting pen holders wet as the metal parts will rust very quickly. Also make sure that all nibs are dried carefully because they too may rust and become useless.

If ink or paint has been left to dry on a nib, soak the nib in warm water with a squeeze of washing-up liquid. The nib should then scrub clean. Nibs only perform well if they are kept clean and rust-free; otherwise, tiny particles of dried ink, invisible to the naked eye, may

inhibit the flow of new ink, particularly if they are lodged in the slit between the tines.

If you cannot clean the dried ink or rust from a nib, be ruthless – throw it away. It will never be pleasant or efficient to work with.

You should also discard nibs if they become damaged. The most usual problem is that the tines become strained, as a result of heavy pressure, careless handling or simply old age. Hold your clean nib up to the light before you put it into the pen holder. If you can see daylight through the slit, sadly the nib is fit only for the wastebin. If the tines are no longer aligned, this again is a strain which cannot be corrected.

It is sensible to check nibs in the shop when you buy them in case they have already been damaged. Occasionally, the slit may not be in the middle of the nib, or it might be missing altogether. Reject the nib and choose another.

Sharpening the Nib

Nibs wear with use and become dulled, but they can be sharpened if you have a fine enough abrasive surface. A small, fine-grained piece of Arkansas stone is perfect for the job but it will probably be expensive even if you are lucky enough to find one. Crocus cloth or flour paper are acceptable alternatives. If you look at your nib under a magnifying lens you will see that its underside is flat but the top has a bevel at the tip which is what gives a sharp writing edge. It is this bevel that needs to be sharpened.

Place your stone or abrasive on a flat surface; if you are using a stone, lubricate it with a drop or two of water. Put your nib into a pen holder and then hold it so that the nib is upside down and the bevel of the nib is lying evenly on the stone. You will be holding the nib at an angle of about 30 degrees to the horizontal stone and the underside of the nib will be facing upwards.

Keeping the nib at a consistent angle, rub it backwards and forwards on the stone; rub gently about six times. Try to keep your pressure consistent. This will probably be enough to restore the edge to sharpness but you will only know by using the nib and getting the feel of it on the paper. If it is still blunt, sharpen it further.

Sometimes a new nib may feel scratchy because the edge has been imperfectly finished. A little gentle 'sharpening' may smooth the nib and make it much more pleasant to use. Or try holding the pen normally and writing a few letters gently on the stone. Remember that you are working with a tiny area of relatively soft metal and the nib will quickly become damaged if you are impatient or harsh. Sharpen a little, try the nib and sharpen a little more. Wash and dry the nib carefully after sharpening as tiny grounds may block the slit.

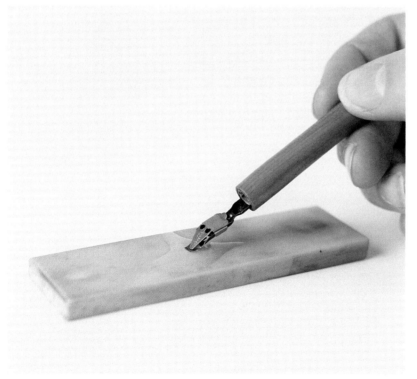

Sharpening the bevel of the nib on an Arkansas stone.

Making Ink

You will need a small ink stone and a Chinese or Japanese ink stick plus a few drops of water to make your own ink. It is possible to buy very expensive ink sticks, but you are most likely to find Chinese sticks which cost little and will make a great deal of ink.

Put a few drops of water onto your stone and rub the flat end of the ink stick to and fro very gently in the water to soften it. After a few seconds, rub the stick more firmly with a circular movement but keep your pace steady and rhythmic. The water will quickly darken. Keep testing the ink on paper with a brush and keep grinding until it is as black as you need it to be. A good quality stick ink will have a distinctive perfume and will be a pleasure to use.

At the end of the day, wash away any surplus ink and clean the stone with an old toothbrush.

The slate stone will eventually, after much grinding, be too smooth to grind the stick effectively. When this happens, rub the grinding surface with some medium-grit wet and dry paper to give it some more 'bite'.

Ground ink has to be freshly made each day, but this is not as time-consuming as it might initially appear. It is also an excellent way of settling down to work, making you move steadily and calmly and concentrating your mind on the work you are about to do.

Filling the Nib

When you first begin, you may find it easier to dip your nib into the ink and wipe the surplus from the top of the nib onto the edge of the bottle before putting pen to paper. However, when you have begun to get the feel of writing, you will want to control the ink flow more effectively.

If you dip your pen into the ink, you will fill the space created between nib and reservoir, but some ink will also cling on top of the nib and under the reservoir. The ink in the reservoir cavity will be released when you press the nib onto the paper, but the ink clinging on top and underneath is beyond your control and will fall onto your work, probably in blobs.

The best way to fill the pen is to feed the ink into the nib with a brush. Fill one of your inexpensive brushes with ink and, holding your pen in your writing hand and the brush in the other, paint the ink along the side of the nib so that it feeds into and fills the reservoir cavity. Make sure that you have not inadvertently painted ink onto the upper surface of the nib. Filling the pen with a brush will give you much better control over the ink flow, helping you to make smoother and cleaner letters.

Have your ink by your non-writing hand and get used to using the brush in your 'wrong' hand. That way you will interrupt the flow of your writing as little as possible.

Holding Your Pen

Think of your pen as an extension of your arm. Hold the pen between your thumb and first finger so that it rests on the first joint of your second finger. The barrel of the pen will then rest in the hollow between your thumb and first finger knuckles, following the line of your forearm.

Hold the pen close to the nib so that you can 'feel' the paper through the nib when you begin to write. There is no need to grip your pen tightly; your fingers are simply a support system and you should try to hold your pen lightly. With experience, you will handle the pen in a more confident and relaxed manner and the weals and white knuckles will disappear.

PEN TO PAPER

When you first put pen to paper, make sure:

◆ that you are sitting at the right height and square on to your paper;

◆ that your board is gently sloping towards you – an angle of about 30 degrees to the horizontal is a good starting point;

◆ that your non-writing hand is resting lightly on your work;

◆ that your ink and brush are within easy reach of your non-writing hand;

◆ that the heel of your writing hand is resting lightly on your guard sheet;

◆ that your pen is held gently, ready to write directly in front of you.

If you are sitting well and holding your pen correctly you will be able to see clearly what you are writing, your hand and arm will be free to move easily and the writing edge of your nib will be making even and firm contact with the paper. If you find it helpful to think in precise terms, the angle between the pen in your hand and your drawing board will probably be between 45 degrees and 55 degrees, but it is more useful to think of finding a position that feels comfortable and allows you to move your writing arm freely so that you can see and feel the good contact between your nib and the paper.

Making Marks

Assemble the pen using the broadest nib and then load it with ink. On a sheet of layout paper draw a series of vertical lines from top to bottom of the sheet. This apparently simple task will probably reveal a number of difficulties.

You may find it difficult to get the ink flowing:

If you put some gentle pressure onto the nib edge, this will encourage the tines to ease apart, allowing the ink to flow more freely from the reservoir. Put the writing edge of the nib onto the paper and rub gently from side to side at the point where you want to begin your mark until the ink appears on the paper, then pull the ink down the paper to make a mark. A dip pen works in this way: by putting pressure on the nib, you enable the ink to flow to the tip of the nib and you then draw that ink down the page with the nib to make marks.

If this does not work, check that the reservoir is correctly positioned. It may be too far back from the nib edge, or the side flaps may be too tight. Or, if you have never used a dip pen before, you may be pressing too lightly. You may need to exert more pressure than you use every day when writing with a ballpoint or fibre tip.

Alternatively, you may be trying to write too quickly. The ink takes time to feed through the slit in the nib, particularly with a large nib which requires a generous supply of ink to cover the writing edge. Slow down.

Finally, look at the slope on your drawing board; it may be too steep, which will inhibit the ink flow.

You may find that the ink is flowing too freely:

Check that the tip of the reservoir is touching the underside of the nib and that it is at least 1mm back from the end of the nib. Check also that you are filling the nib correctly.

Be sure that you are not pressing too hard. If you are, the tines of the nib will spread apart, making a line which is wider than your nib. Again, take a look at the angle of your board, it might need to be a little steeper. If you are still having difficulties it is possible that you have chosen an ink that is rather thin and is flowing too quickly.

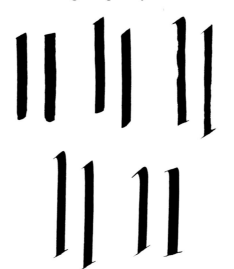

Unsatisfactory marks may be caused by (left to right) too much pressure on the nib or too much ink; too thin ink; uneven or hesitant pressure across the tip of the nib.

Satisfactory marks should have smooth edges and neat beginnings and endings.

When you have persuaded the ink to flow correctly, spend some time drawing long vertical lines. This will help you to get the feel of the pen and the paper, and to get used to reloading the nib. The lines you draw will not, of course, be straight but the wobbles don't matter. At this stage, the feel of what you are doing and the movements you are making are more important than the look of the lines you are drawing.

Try to make the lines by moving your arm. Pull back at your shoulder and elbow; don't bend your wrist or your fingers. Move as steadily as you can. Gradually you will feel a rhythm developing; this will be very important when you begin to write.

Keep the pressure on your nib as regular as you can manage. You want the layer of ink on the paper to be as even and consistent as possible. This again will affect the quality of your marks when you begin to write.

THE ANGLE OF THE NIB

Continuing to use your largest nib, try to reproduce these marks. Always keep the full edge of the nib on the paper.

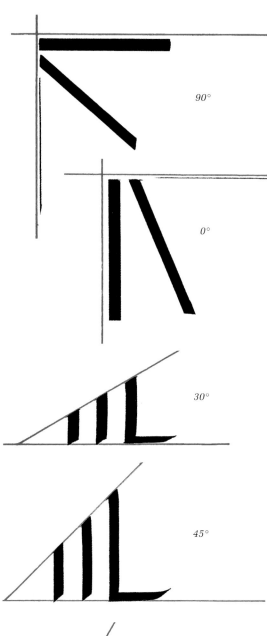

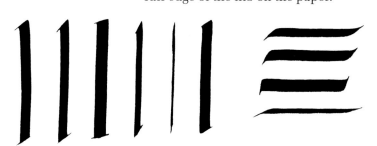

When calligraphers speak of the angle of the nib, or the pen angle, they are referring to the angle on the paper created between the horizontal writing line and the writing edge of the nib. It is possible to make a wide variety of different marks by changing this angle.

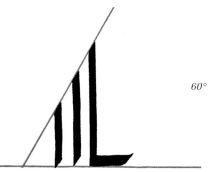

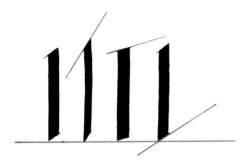

The angle at which the pen was held to make a letter can be measured by marking the end of a pen stroke.

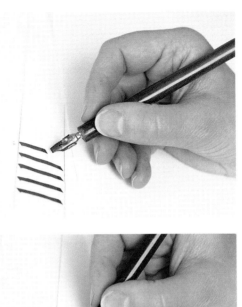

When studying a formal hand it is essential to be aware of the pen angle which you are using, as your choice will affect the character of the strokes that you produce.

If you then discipline your marks into a pattern, you will see the effect of the pen angle more clearly.

It is important to continue to move evenly and steadily so that you begin to develop your own writing rhythm.

Try to make your patterns as even as possible. You will notice that certain pen angles enable you to move more freely than others. Holding your pen at an

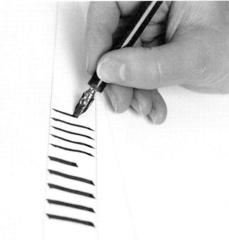

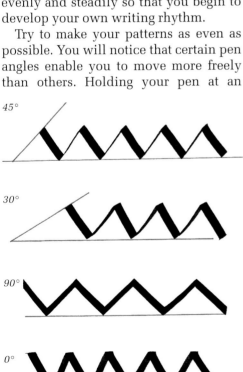

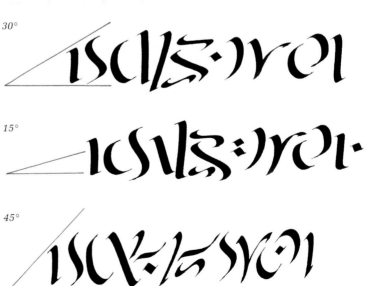

angle of 90 degrees or 0 degrees will generally feel less natural than 45 degrees.

You will also realize that certain movements are more difficult than others. Usually, vertical movements, pulling down the page, will be easier to make than horizontal movements or vertical movements which push up the page. Formal calligraphic writing takes account of these difficulties. Most letters are constructed by making two or more strokes so that the pen can be handled with as much ease as possible and, consequently, with as much control as possible.

WEIGHT OF LETTERS

The pen angle with which letters are made has a strong influence on the look of the writing produced. If you write with a consistent pen angle, the thickness of the strokes will vary according to the direction in which your pen moves. The height of your letters is an equally important decision.

Because you are working with a broad-edged tool, which produces lines of varying thickness, the proportion of black mark to white space within your letters will vary according to the height of the shapes you make.

If you hold your pen at 45 degrees to the horizontal and draw a square 10mm (⅜in) high, you will create a tight little box. If you then do exactly the same but make your square 100mm (4in) high, the lines in both squares will be of a consistent thickness but the white spaces inside each square will be very different, the relative proportions of black and white creating quite different images. Calligraphers define this proportion by measuring the width of the nib used and measuring the relative height of the letter in nib widths.

To measure the width of the nib, hold the pen at 90 degrees to the writing line and make a neat square mark. If you want letters that are four nib widths high, add three more blocks, making a staircase. Your blocks should just touch each other but not overlap. You now have the measurement for guidelines for letters four nib widths high while you continue to use the same nib.

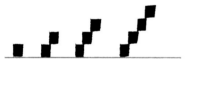

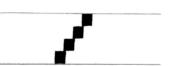

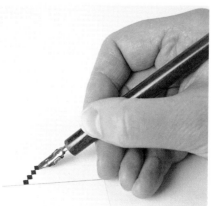

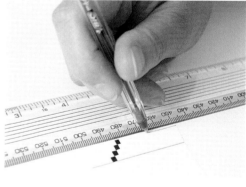

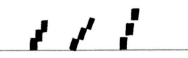

Make sure that you aren't overlapping your squares, holding your pen at the wrong angle or leaving spaces between the squares.

cheerful *cheerful*

cheerful

Changing the weight, but using the same pen, creates very different images.

Ruling Guidelines

For your initial studies of a formal script you will need to write between guidelines so that you can learn the feel and look of the correct letter proportions. Ruling guidelines is not a complicated process but it must be done as carefully and as accurately as possible:

- First, take your pen and make a staircase four nib widths high. This gives you the measurement of what is sometimes called the x height, or the body height, of your letters. Different scripts require guidelines with different x heights; these particular guidelines will be useful for your Foundational hand studies.

- Now either set your dividers to the x height or transfer the measurement to the edge of a paper strip.

- Rule a pencil line across a sheet of layout paper about 30mm (1⅛in) below the top edge. This now

becomes the top of your first set of guidelines. Using your dividers, or your measured paper strip, mark pencil dots down the left margin in equal x height steps. Do the same at the right edge of your paper. Take a ruler and carefully join the first pair of markings across the page. This will give you a set of guidelines with an x height of four nib widths.

- A T-square can be a useful and faster way of ruling parallel lines provided that you handle it accurately.

Continue down the page until you have a full set of parallel lines. If you write only between alternate pairs of lines, this will be adequate for your first exercises. Later, it will be necessary to consider the spaces between the lines of writing.

When the piece of work is finished, your fine, lightly ruled markings can be removed with a soft eraser.

GUIDELINES WHEN RULING:

- ◆ use a really sharp pencil
- ◆ rule as fine a line as you can
- ◆ use an accurate long ruler
- ◆ be as careful and painstaking as possible.

Do not forget that when you change your nib or the script that you are writing, you must begin again by measuring the appropriate number of nib widths.

It is possible to buy ready-ruled guidelines to put under your work sheet, but these may not be as precise as you require. Nibs vary and change with use and wear, so your three No. 1 nibs may

BASIC GLOSSARY

Most of the terms calligraphers use to describe letters, parts of letters or writing are in common parlance and meanings will be self-evident. Following is a summary of the terms that you are most likely to encounter.

Letters are either majuscule:

MAJUSCULE

or minuscule:

minuscule

be slightly different from each other, requiring different rulings.

Remember that the purpose of ruling guidelines is to help you to learn the size and proportion of the letters. If your guide lines are not accurate, they will not be any help and you will have wasted your energies.

When you can write confidently, you will be able to manage without a top guide line and possibly without any lines at all. Lines form a sort of scaffolding; while the building is in progress, they offer a support system which is vital, but when the building is complete, the scaffolding can safely be removed.

Majuscule forms are of an approximately uniform height and the word majuscule is virtually interchangeable with 'capital', although capital is more usually used to refer to the initial majuscule at the beginning of a sentence or which denotes a name or proper noun. The equivalent printing or typographic term is 'upper case'.

Minuscule forms, also called lower case, are not of a uniform height and some of the letters within an alphabet have ascenders or descenders.

Monoline
Monoline letterforms are made up of strokes that are all of the same width, such as those made with a pencil or a technical pen. Calligraphers sometimes refer to these as 'skeleton letters'.

Weighted Letters
Weighted letters include those made with a broad-edged nib and the strokes vary in

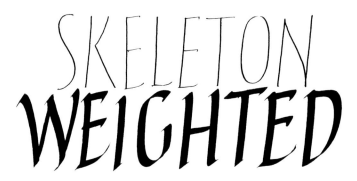

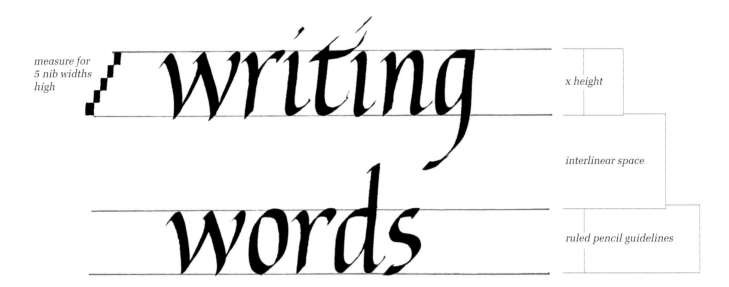

measure for
5 nib widths
high

x height

interlinear space

ruled pencil guidelines

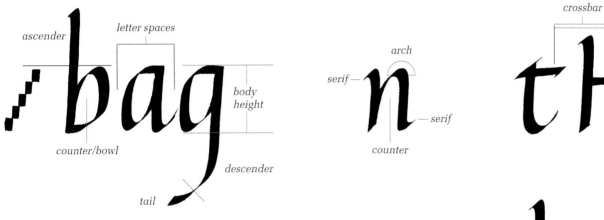

ascender

letter spaces

body
height

counter/bowl

descender

tail

arch

serif — n — serif

counter

crossbar

tH

waist
line

diagonal strokes

width according to the angle at which the pen is held and the direction in which it travels.

Script and Hand
A script and a hand are both terms for a style of writing. If a calligrapher makes any distinction between the two terms, it is usually that a hand is the personal version of a standard model script.

WORKING PROCESSES

The x height, or body height, is determined by the script and the nib being used. The interlinear space will usually be larger than the x height.

Parts of a Letter

The counter of a letter is the space inside that letter. For example, because b has a bowl, the counter is entirely enclosed, whereas in n, which has an arch, the counter is only partly enclosed. The letter space is the space between letters in a piece of writing.

The serif, as you will discover, serves the practical purpose of starting the ink flow at the beginning of a stroke and then

tidying it up at the end. It can, however, be a decorative feature and the choice of serif has a strong influence on the visual character of a piece of writing.

Characteristics of Writing

Most formal letters are made up of two or more pen strokes. The direction and sequence of these strokes is called the ductus and, as far as possible, this should follow the logical movement of the writing hand from top to bottom and from left to right across the page, giving the writing both rhythm and an even flow.

Each hand has a natural writing speed. This will be affected by the pen angle and the manner in which the letters are constructed, but all writing, when it is fluent and confident, will tend to slope forwards. It is always necessary to begin studying a script by working

writing will develop a distinctive slope and, because the pen is lifted only infrequently from the page, hairline ligatures will develop, giving the writing a cursive, linked appearance.

ligatures

Form and Pattern

To make a study of a formal script you will usually need three pieces of information that essentially define the character of that script. You need to know how to hold the pen, that is the pen angle, and the proportions, the weight, of the letters. These two elements have already been considered. The third piece of information you must have is the underlying form that characterizes and unites the letters into a harmonious alphabet. The key letter most usually is the letter O which indicates the proportions and formation of all other letters.

slowly and deliberately, but in time you will find that some styles of writing become quite quick and informal. Such

3 Formal Letter Studies

Formal writing is essentially pattern making. A pattern is repetitious, it is regular and even, it is often simple. To be visually interesting it needs a little variation within it, but not so much that it loses its regularity and ceases to be a pattern.

The pattern of a formal script comes from the regular movement, almost like a beat, of the hand that is making the writing and from the aesthetic judgement of the eye which then assesses the results. Certain refinements to the script may be made either because of the flow of the hand or because of the look of the letters, but essentially a good script will feel comfortable and flowing to produce and will look harmonious and pleasing. Because we are so used to printing and the conformity which that imposes upon letter shapes, we tend to think of 'good' writing as being completely regular, every letter 'a' being exactly like every other letter 'a'. In reality, the regularity of good writing is much more subtle and idiosyncratic. The calligrapher has the idea of letter 'a', what it should look like and how it should be constructed, and this is what he or she tries to do every time 'a' has to be written. The idea is clear in the mind and the hand responds to this idea but inevitably the hand wavers. Although a skilled calligrapher will produce letters which to most eyes appear to be identical, it is the slight variations, sometimes happening by chance and sometimes deliberately imposed by the calligrapher, which help to give a hand-written text its life and vitality.

We are surrounded by print and it leads us to expect uniformity, straight lines, justification to left, and sometimes to the right; it creates certain expectations about scale, about colour and illustration. But the uniformity of print is a mechanical uniformity. The printed page is the repetition of the same mark. The written page is the repetition of the same idea.

The mediaeval scribe, working before the invention of printing, had a different philosophy. The regularity of his writing was a result of his skill, of the disciplined rhythm of his movements and the clarity of his intentions, and of the critical sophistication of his eye. If he repeated movements as he wrote and kept to a steady rhythm, then he could write relatively quickly and easily, and the writing would look good because it had visual regularity; it made a pattern. We can usually see the pattern in formal writing, but our familiarity with letters and with everyday writing and printing can make it difficult for us to imitate the pattern accurately. We are used to recognizing letters quickly and easily for the purpose of reading and understanding. However, we don't really 'see' the writing because we can interpret what it says, sometimes without many visual clues (consider some of the handwriting you have met!) and we 'look through' the writing to the meaning it carries.

The study of a calligraphic script requires an understanding of the overall

WHEN MAKING PATTERNS:

◆ hold your pen at a consistent angle

◆ try to make your zigzags as equal as you can

◆ try to move evenly and smoothly

◆ touch the top and bottom guideline with the points of the zigzags

◆ be as precise and accurate as you can.

pattern of the writing and a critical eye for detail. It means trying to look at letters with fresh eyes and to see the reality of what is happening under your pen.

MAKING PATTERNS

To study a formal script, it is useful to find the pattern that holds the writing together before you try to write individual letters. You need to know the usual pen angle and the weight of the letters and the underlying letter form. It is helpful if you are a beginner to get the feel of these elements into your hand before you begin to write.

Always use a large nib for your initial studies. Large marks are easier to improve on because you can see more clearly what you are doing.

the pen angle and the letter weight you will be surprised at how accurate your efforts will be. Invent other patterns, but keep them simple and be as accurate as you can.

Keep within the guidelines but try to touch them with every stroke and continue to hold the pen at an angle of 30 degrees. The white spaces are just as much a part of your pattern as are the ink marks and you might find it useful to look at the white shapes that you have created; do they echo each other? Do they have the same regularity as the ink strokes?

If you then repeat the basic pattern shapes but change the angle of your pen, you will see at once how the pen angle influences the appearance of the line.

Having absorbed the feeling of the correct pen angle and letter weight for the script you intend to study the next task

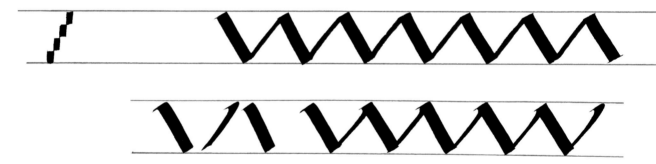

First, rule some guidelines which are four nib widths apart for the large nib you are using. With your pen held at an angle of 30 degrees, make a row of zigzag marks between the first set of guidelines.

You may find that the friction between nib and paper on the up strokes is too great for comfort. Try making all the strokes by pulling down from the top guideline, but keep the movement and the pattern as even as you can.

Now try the same thing with your eyes closed. If you have learned the feel of

is to look for the repeated marks which made up the pattern of the alphabet.

A sound calligraphic minuscule alphabet is not made up of twenty-six abstract shapes, each one to be learned in isolation and probably with considerable difficulty. It is made up of a surprisingly small number of marks, which grow from the regular repeated movements of the calligrapher's hand and which are arranged in various combinations to make up twenty-six letters, creating an alphabet which has visual unity.

REMEMBER:

◆ If you are working from a book, the image you are using will have gone through several reproduction stages and may have lost something in translation.

◆ If you can possibly manage to see the real thing, you will not regret the effort involved.

◆ Most scripts have a natural scale. Look for the information giving the real size of the writing.

◆ Mediaeval manuscripts were most usually written with quills on vellum; don't expect your steel pen to be capable of reproducing exactly similar marks. The tool and the surface always inform the writing, so you will need to adapt and modify certain of the marks. You may also need to adapt and modernize certain letters to make them legible to a contemporary reader.

◆ The original scribe was using his writing to make an artefact which was to serve a particular purpose. Any modern adaptation of an historic script should be made with its eventual use in mind.

◆ Writing which you choose to use as a model need not be mediaeval; there are many contemporary scribes whose writing is well worth careful study and analysis.

companion
ncon

The shape of the letter o gives the starting point for the pattern of a hand.

companion ncnc

companion ici

These marks, which of course vary from script to script, are the source of the close visual relationship between the letters.

If you look at the basic marks of the alphabet before you try to write individual letters you will understand the pattern of the script and it will be much quicker and easier to learn than copying twenty-six shapes would be.

ORIGINAL SOURCES

Contemporary calligraphers frequently use historical manuscripts as models for their own writing and the scripts described in this book are all based on specific historical examples. The advantages of this approach are that you are using real writing as your model and so can be sure that the letters will run together fluently. You also have an idea of the look and character of the script, and can choose to work with examples which demonstrate the highest skill and fluency. There are many excellent reproductions of manuscripts in calligraphy and other books, and when you have a little experience you will find it rewarding and not too difficult to work from a copy of an original rather than from someone else's version of it.

4 Foundational Hand

The Foundational hand is based on the writing of the Ramsey Psalter, MS Harley 2904, now in the British Library in London. The Psalter was written in the south of England, possibly at Ramsey Abbey near Huntingdon or possibly at Winchester, towards the end of the tenth century. The text is in Latin and the script is an example of English Caroline minuscule. The writing is quite large, it is bold and clear and was obviously produced with great skill and confidence. As with most mediaeval manuscripts, the scribe remains anonymous.

Inevitably, the name of Edward Johnston is linked with twentieth-century versions of the script. In the late nineteenth century the Arts and Crafts Movement regenerated an enthusiasm for manuscripts, illumination and calligraphy; William Morris was himself a calligrapher and made and decorated manuscript books. Edward Johnston continued in this newly re-established tradition. At the turn of the twentieth century he was researching, writing about and teaching formal penmanship and became largely responsible for establishing formal broad-edged pen calligraphy as a modern living craft in the United Kingdom. He devised the original Foundational hand using the Ramsey Psalter as his model because he believed that this hand would give his

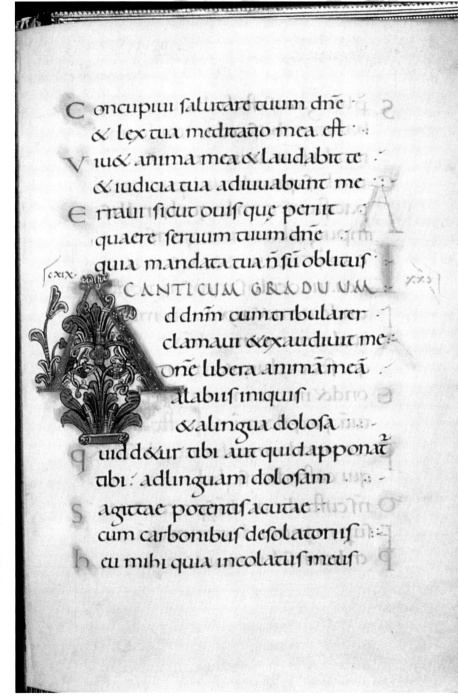

From the Ramsey Psalter, British Library MS Harley 2904. Probably written between AD 974 and AD 986. Page size 330 × 250mm (12¾ × 9¾in).

students a good foundation on which to base their calligraphic studies.

FOUNDATIONAL AS A BEGINNING

Many calligraphy teachers use Foundational hand as their students' first study; others begin with another script. Again, this is neither right nor wrong, it is simply different. I use the Foundational hand to introduce beginners to formal calligraphy for several reasons:

- The original manuscript is very clear, so the inexpert eye can decipher and appreciate it with relative ease.

- It was written by an excellent craftsman; always choose the best model you can find.

- Foundational hand as devised by Edward Johnston is logical and consistent. Like the Ramsey Psalter, it lacks idiosyncrasies or affectations.

- The underlying form is the circle. This is an excellent shape to begin

with because a circle is an absolute; everyone knows what a circle is. Consequently, it is not difficult to recognize the pattern in the writing.

- The pen is held at the same angle for most of the alphabet.

- It is a useful script, particularly where clarity and legibility are essential.

- It can easily be adapted for freer, more experimental work.

When you have learned to write Foundational hand and have understood the principles that underlie the structure, the relationships between letters, the movement of the pen and the character of the writing, you have enough knowledge to analyse, write and use any formal calligraphic script.

The Character and Uses of the Hand

The script is round and, in its historical model, quite large; it is constructed in a deliberate and disciplined manner and the relatively large number of pen lifts makes it slower to write than more cursive scripts such as italic. This gives the writing of the Ramsey Psalter a comfortable formality; it looks important but not grand, it looks energetic and strong but contained.

All these are characteristics of a well-written contemporary Foundational hand. Because the rhythm of the pen strokes is deliberate and controlled, the writing does not lend itself to exuberant flourishes or decorations. At its best it is firm, clear and very legible. It is particularly useful to the calligrapher who has a

The Ramsey Psalter, detail.

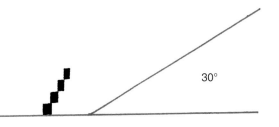

30°

you took away the weight of the marks created by the broad-edged pen and reduced the letter to its monoline form, it would be a circle.

The letter o is not a circle round its circumference, nor is the white counter a circle; rather, think of each corner of the nib as drawing a circle.

THE PATTERN

Foundational hand is made up of a few visually simple strokes.

If you practise these carefully between guidelines and with the correct pen angle, you will find that learning the letters comes quite quickly.

Rule the guidelines as accurately as you can. Hold your pen at 30 degrees and keep checking that your angle is

substantial amount of information to present, either in broadsheet or book form, for whom legibility is the priority, or whose text demands a certain authority in its visual presentation.

ANGLE, WEIGHT AND FORM

The pen angle for most of the letters is 30 degrees. The group of letters at the end of the alphabet which are made up

of diagonal strokes are written with the pen at a slightly steeper angle for aesthetic reasons.

The weight is four nib widths high. You will find some books and some teachers suggest a weight of four and a half nib widths which comes from the teachings of Edward Johnston, but many of us prefer to use a weighting of four nib widths. The look of the writing is then stronger and closer to that of the Ramsey Psalter.

The underlying form of the letters is a circle. Look at the letter o of this script; if

consistent. Move steadily, don't hurry and resist the temptation to flick your pen off the page at the end of a stroke.

Letter Groups

The first stroke is half a circle. Begin just below the top guideline where your mark will be at its thinnest, pull round in a half circle until the pen begins to push up, and lift off gently. This is the first stroke of several letters.

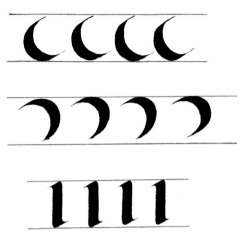

The construction of the first group of letters uses elements of the circle and/or a straight line.

To add a second stroke put the pen back into the mark you have made so that you are picking up the wet ink already on the paper. Always join strokes by overlapping them if possible. The second stroke completes the circle o and again is repeated in other letters. If you find it difficult to draw a smooth circle, try watching the corner of your nib instead of the whole stroke.

The third stroke is a straight line, important because it defines the serif. The movement of this script is steady and controlled, the underlying shape round, so the serifs must echo this.

Make sure that the line is straight from guideline to guideline with a neat curved serif at top and bottom.

The letter j is made exactly like i but is continued below the base guideline, the pen being lifted off when it begins to push. To dot the i and j, put your pen onto the paper and move it lightly to the left and lift off. It will become more elegant with practice.

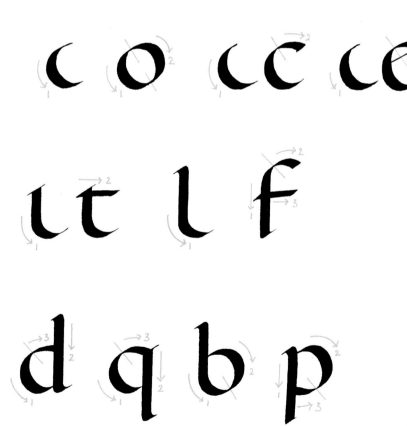

The base of l and t pick up the curve of the circle in o. This curve is also echoed in the top of f. Crossbars hang from the upper guideline and are wide enough to create a square image in t and in the top of f. Try dropping the crossbar of f minimally as this may give you a better balance of white inside the letter. Check that you are keeping your pen angle at 30 degrees for the horizontal strokes.

Note that the first stroke of b is exactly the stroke which is l.

The third stroke of both d and p which fills the space between the half circle stroke and the straight stroke is a very shallow, almost flat curve. This avoids a heavy join at the stem.

o c e í j

t l f d q b p

Look at the white counter spaces inside the round letters. If you are making the black marks correctly all the white spaces should echo each other.

ASCENDERS AND DESCENDERS

The appearance of the script is solid and compact, so ascenders and descenders need to be kept quite short so that they are in character. Look at the Ramsey Psalter and you will see that ascenders and descenders do not extend far above or below the body height. If you make them about three, and certainly not more than four, nib widths long, you will keep the round, sturdy character of the script.

Some teachers suggest drawing further guidelines for ascenders and descenders; if you are finding it very difficult to estimate the lengths, this may be helpful, but I suggest you see it as a last resort. If you look carefully at what you are writing, it usually does not take long for your eye to learn to estimate accurately and you will save preparation time.

However, having ascenders and descenders meticulously equal in length is not only unnecessary but undesirable; it imposes a rigidity on the appearance of the writing that is more appropriate to print than to the handmade. Variety within the pattern – but only a little – gives vitality and interest.

The wobbles of inexperience will be most evident in the longer strokes and you will probably worry because it is difficult to write a straight line. Knowing your letter shapes thoroughly and handling your pen with confidence will improve the quality of your marks in time, but from the beginning be aware of your breathing. If you take a breath, put your pen on the paper and exhale as you pull the stroke down the page, you will have more control over the movement and the wobbles will begin to disappear.

The fourth basic stroke to learn is the arch which follows an arc of the circle. Check that your pen angle is 30 degrees. Put your pen into the down stroke just below the upper guideline and pull the curve up to the line, round and then straight down.

mmm uuu

The inside white counter should be gently rounded and as symmetrical as you can manage. Think of it as a Norman arch. Make the arch stroke exactly the same whatever the letter. Try watching the left-hand corner of your nib as you write the arch rather than the whole stroke.

n h m u a r k k

n h m u a r k

The construction of the second group of letters is based on the arch shape.

POINTS TO CHECK:

◆ that your pen angle is 30 degrees;

◆ that your arch shapes match each other;

◆ that your down strokes are consistent;

◆ that your serifs are consistent; look particularly at the feet where it is all too easy to relax and lift the pen from the paper with a flick, giving you large and spiky serifs.

The letter u is the arch upside down; a uses the arch for its back. Put your pen into the side of the arch to pick up the wet ink, pull it sideways and then curve round back into the side of the letter. The arc of the circle at the bottom of the letter echoes the top arch. The letter r begins like n but the stroke then continues horizontally. The appearance of k is often lightened by leaving the bowl open. Look carefully at the point where the diagonals join the stem by just touching rather than breaking into the stem. Again, this lightens the letter.

The fifth stroke is the diagonal used in the last few letters of the alphabet. Lift the pen and make each stroke separately by pulling down from the top guideline.

The letter w is v twice; y is v with the second stroke extended to make a tail.

Remember to overlap the strokes. The diagonal letters relate to the dimensions of o; v at its widest point is almost as wide as o at its widest point, and all the other diagonal letters match v. To look upright, these letters should be symmetrical. This, together with neat joins, will come with practice.

Notice that the pen angle changes for these letters. If you write v with the pen held at 30 degrees, you will see why. Both strokes are heavily weighted and meet in an ugly wedge. Turn your pen to about 40 degrees and the balance between thick and thin strokes becomes more elegant and pleasing.

My pen angle is not consistent – different pen strokes demand different pen angles. Look carefully at the examples and at the letters you are making and turn your pen as necessary.

The third group of letters uses diagonal strokes.

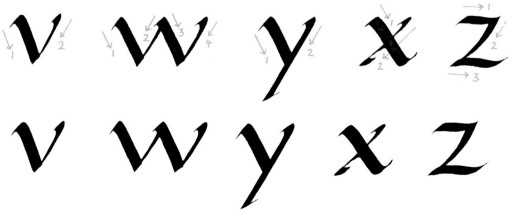

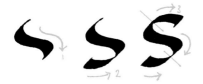

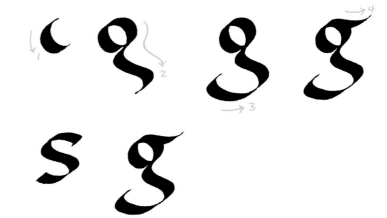

This leaves only two letters which don't fit into a family group.

For these, the pen angle is 30 degrees. The letter s at its widest point is almost as wide as o. The first stroke must have a strong horizontal pull to give the letter its necessary width. The top and base again echo the arc of the circle, but are very shallow curves to give the letter stability. Try to keep s upright; don't make either the top or base so long that the letter tips forwards.

The top of g is a circle, but about two-thirds the size of o. It hangs from the top guideline to leave plenty of room for the tail. The small 'ear' at the top is necessary to give the letter balance and to carry the reading eye forwards. It helps to think of the g as having a centre spine which keeps the letter upright and balanced.

HOW TO PRACTISE

Your first task must be to learn to write the letters without reference to these studies. This will happen more quickly if you work on the letters in their related groups because your hand is repeating movements and your eye is looking at similar marks and patterns. Don't try to write out the alphabet; that's making things too difficult at this stage.

Think about your pen:

- Is it moving smoothly over the paper?

- Are you putting the whole of the edge of the nib onto the paper?

- Is your pen angle correct?

Think about the marks you are making:

- Are they clean edged and crisp?

- Are the curves really smoothly curved?

- Are the straight lines becoming straighter?

- Are the serifs small and neat?

Think about your movement:

- Are you beginning to write steadily and with a regular pace? Try closing your eyes and writing a few letters. That will help you to feel whether or not you are moving your arm in a relaxed manner.

- Are you comfortable and sitting well?

- Have you remembered to breathe at the right time?

Think about the letter shapes:

- Work on a single stroke and all the letters in which it appears.

◆ Remember that the white counter is just as much a part of the letter as the black mark and try to get used to looking at the white 'spaces' from the beginning.

◆ Are you following the suggested stroke sequence? Again, you will find other calligraphers suggest slight variations on the version I have given. There is nothing incorrect about this, but remember that the movement of your hand should be easy and that whenever possible we write from left to right.

You will have noticed that I am quite enthusiastic about the idea of thinking. It is all too easy to write on automatic pilot, covering sheets of paper but learning very little because you are not thinking about what you're doing. Making progress means plenty of writing but it also means looking closely, being critical and analytical and knowing exactly what you are trying to achieve.

POINTS TO REMEMBER:

◆ Do not grip your pen too tightly. You'll forget, of course, because you are anxious and trying hard. Try putting your pen down every 15 minutes or so and wriggling your fingers.

◆ Do not tense your arm, neck and shoulder muscles. Do not write for more than 30 minutes without standing up or moving your shoulders and turning your head from side to side.

◆ Change the focus of your eyes regularly. If you concentrate for too long on your page your eyes will tire. Look across the room or out of the window so that your eyes have to re-focus.

◆ And don't forget to breathe!

When you are first learning letters, try some of these suggestions:

◆ Don't write the same letter over and over again; try writing one letter ten times and then ask yourself which looks the best, which felt the best to write, which is the poorest and why. Give yourself pencil ticks and crosses. Then go on to another letter.

◆ As soon as you know enough letters, write words.

◆ At the end of every three lines of practice, stop and criticize what you've done. Maybe just look at all the serifs or all the round letters. Tick the best bits with a pencil.

◆ Invent sentences and phrases which contain as many examples of the letter you want to practise as you can think of – amiable aardvarks and giggling geese are quite useful here.

◆ Write without looking at the models as soon as you dare, but check back every so often to make sure you haven't strayed too far.

NUMERALS AND PUNCTUATION

Numerals

The system of ten Arabic numerals 0–9 which we use today reached Europe

1 2 3 4 5 6 7 8 9 0

about 1,000 years ago, but did not achieve widespread acceptance until the Renaissance. Consequently, it is usually impossible to find authentic period numerals to go with an historically based hand, so we have to invent appropriate figures.

Numerals for Foundational hand must reflect the character of the writing. The zero echoes the letter o, and the other figures are chunky and round. The pen angle is 30 degrees, the weight is four nib widths high.

The serifs on 1 and 4 are made by lifting the pen and adding a separate stroke to give a more formal finish. The bowls of 3 and 5 echo each other, and 6 and 9 are almost reverse images.

When writing numerals try to keep the same movement and rhythm as when writing letters.

Punctuation

Although occasional punctuation markings have a long history, there was no system of standardization until after the invention of printing, so historical references are limited.

The pen angle is 30 degrees. Keep the marks neat and in character with the writing.

Commas and full stops rest on the bottom guideline quite close to the final letter. Inverted commas are reduced to single commas and sit just above the upper guideline. Keep exclamation marks straight and question marks rounded. Semicolons and colons look best if they lie clearly inside the guidelines.

Punctuation marks serve the utilitarian purpose of aiding communication and understanding. In a calligraphic work, such marks are sometimes intrusive and it is always worth considering whether they are really necessary. A piece of work comprising a single sentence does not need a full stop to indicate the end of that

sentence, and in a formally designed piece such as a certificate or an invitation, the pauses and full stops are usually indicated visually by the arrangement of the text.

If you are using someone else's poetry or prose for a piece of work, the decision may be a little more complicated but it is your decision. Writers may punctuate their work just as carefully and thoughtfully as they choose the words and if you feel that you should reproduce the text exactly as it was created, including punctuation marks, then that is what you must do. However, you may feel that your visual interpretation of the text makes the meaning and punctuation perfectly clear without the need for marks or, as I think is often the case with poetry, you may find the text so skilfully constructed that marks are superfluous anyway. If you feel that punctuation marks serve no purpose, omit them. Every context is unique and for each piece of work it is important to make a considered decision with which you feel comfortable.

SPACING

Letter Spacing

If letters are spaced at regular intervals, the pattern of the writing will appear even and easy on the eye, making the written text as legible as possible. Even spacing will begin to happen if you are writing with rhythm and are learning to look at the inside white shapes of your letters, but it is important to understand what you are trying to achieve so that your eye can learn to evaluate.

Look at this upside-down word:

ɟoundɐtional

What you are aiming for is a reasonably even balance of black and white along the line, which means that white spaces between letters balance with the white spaces inside letters. This cannot be done mathematically or by measuring because there are too many variables, but there are several points to look for:

- The letter o gives the basic form to this hand and the space inside o should balance with all other white spaces in the writing.

- The space between two vertical strokes will probably need to be wider than you expect.

- The space between two curves needs to be quite small where the curves are at their closest.

- Try shading the spaces between letters to see whether you are creating evenly balanced areas.

Evenly spaced writing allows the eye to travel quickly and to read easily. It creates a pleasing texture on the page. If you look at a piece of work upside down you will find it easier to recognize uneven spacing. Sometimes, writing is unevenly spaced for visual effect, but this must be done deliberately and with understanding.

Word Spacing

You will probably find when you first write a sentence that your letters need to be a little further apart than you expect and your words a little closer together. Between your words you need just enough of a break to indicate the sense without interrupting the reading eye's travel along the line or the visual aesthetic of a ribbon of beautiful writing. The space between words need be no wider than an o.

The eye takes time to learn, but even an inexperienced eye is remarkably subtle if you allow it to be. Always listen to what your eyes say.

**walk fast in snow
in frost go slow**

5 Roman Capitals

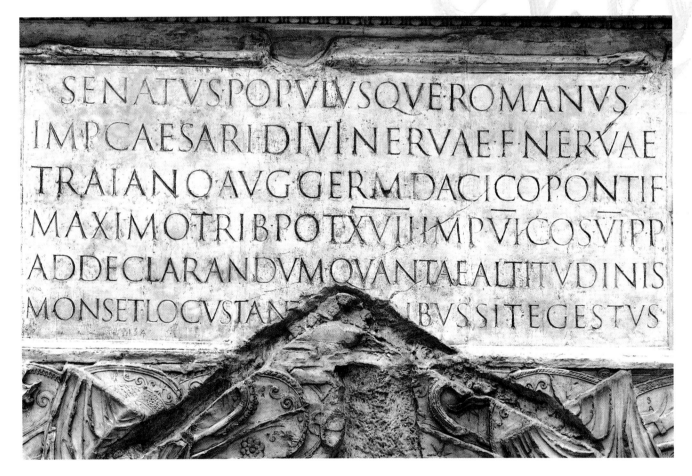

Almost all the Western letter forms in use today derive from the majuscule letters of Classical Rome and there are many fine examples extant both in Rome and throughout what was the Roman Empire. At their best, the letters are beautifully proportioned, skilfully made and elegantly spaced and they have received the attention of academics and artists as well as letterers. Because of its subtlety each letter can be profitably and pleasurably studied as an abstract shape.

The most usual reference point for calligraphers is the inscription on Trajan's Column. The column, built in the second

This moulding taken from Trajan's Column, Rome, is in the Victoria and Albert Museum, London. The letters are approximately 110mm (4⅛in) high.

century AD to celebrate the military victories of the Emperor Trajan, stands in Trajan's Forum in Rome. A marble panel on the pedestal of the column carries the incised inscription. The letters have a balance and a clarity which suggest that great skill and aesthetic understanding went into their making. Because of their historical and artistic importance, Roman capitals are an important study for all calligraphers, although using incised letters as a model for an alphabet written with a broad-edged pen presents us with significant problems of adaptation.

ADAPTING FOR THE PEN

These points should be borne in mind:

◆ The letters on Trajan's Column are about 110mm (4⅓in) high.

◆ They are incised.

◆ They are grandly monumental, created to serve the political purposes of the Emperor.

◆ They are in a public place.

◆ Many other examples of Roman capitals from the classical period were made for similar reasons and to similar patterns.

The calligrapher using a broad-edged pen is working to a different scale, usually to a much more intimate purpose and, as the tool always informs the mark, finds it impossible to reproduce exactly the inscriptional letters of Classical Rome. To adapt Roman majuscules for the pen we must find the essence of the letters. This may sound somewhat mystical, but it means paring down until we can recognize the underlying structure and the essential qualities of the letters.

This is rather like reducing an animal to a skeleton with personality. The next stage is to build on that skeleton with the pen. This will result in pen-made letters that, when compared with the original incised letters, are made differently, look different and have very different characteristics but which share an essential likeness.

A sound study of pen-made Roman capitals goes through three stages, which consist of a geometric analysis made with ruler and compasses, moving on to freehand skeleton forms which are then weighted by using an edged pen.

GEOMETRIC ANALYSIS

The analysis of Roman capitals which follows is an attempt to reduce the letters to essential forms, to take away anything unnecessary so that the simplest skeleton is exposed. Some scholars believe that there was a geometric basis for the construction of the finest Classical inscriptions and so this way of thinking about majuscule forms probably has a long history.

It is important to appreciate that even at this minimalist stage, adaptation and interpretation relevant to the calligrapher are already being made. This is not a direct analysis of the inscription on Trajan's Column. If you look at those letters you will see, for example, that O is oval rather than a pure circle, that M and N are 'too wide' according to this analysis, and some letters do not even appear in the inscription and have had to be invented. The skeleton forms of the Trajan letters have been rationalized and adapted so that they fall into related family groups, because that is how pen-made alphabets work.

These groupings create a logic and an understanding on which the pattern of weighted pen-made letters, using

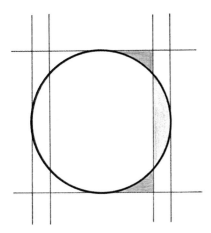

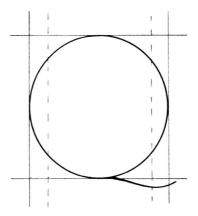

repeated rhythmic pen movements and marks, can be built.

It is worth taking time to draw out the alphabet, using a pair of compasses, a ruler and a sharp pencil or fine-tipped drawing pen. Be as accurate and as neat as you can, and take your time. This care and attention to detail is all part of learning to be a good craftsman.

Working steadily will help you to learn the relationship between letters and their related groupings. Roman majuscules are of an even height. There are no ascenders or descenders, so the relative widths of the letters become very important to the visual pattern and variety.

The basis of this study is a circle, a square and a rectangle. The diameter of the circle is equal in length to one side of the square. The circle is drawn inside the square. You will find a diameter of 40mm (1½in) gives easily manageable proportions. A rectangle is then constructed inside the square, cutting off one-eighth of the width of the square on each side. The area of the rectangle is visually equal to the area of the circle.

The Round Letters are O Q C G D

◆ O is a perfect circle, Q a perfect circle with a tail.

◆ C is a half circle. The line is then continued along a slightly shallower curve at the top and bottom until it meets the side of the rectangle.

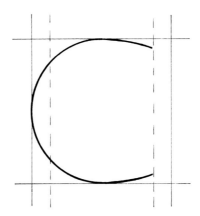

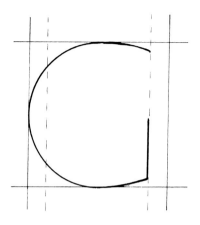

- G is made exactly as C but with a flat half side on the right.

- D uses the right half of the circle with the side of the rectangle for its back.

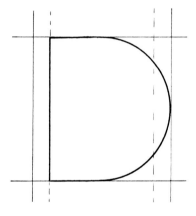

The Rectangular Letters are
H T U A N V X Y Z

At their widest point, these letters are three-quarters the width of O.

- H, U and N use the sides of the rectangle.

- U is the only letter in this group which uses an arc of the circle.

- H and A have horizontal crossbars. If you rule these lines through the centre of the circle, you will notice that the balance in A is rather uncomfortable and will need to be adjusted when the geometric A becomes a letter.

- X and Y both have junctions on the centre point of the circle.

- The vertical in T passes through the centre of the circle.

- The lines of V meet in the middle of the base of the rectangle.

The Wide Letters are M and W

- The centre of M is a V using the width of the rectangle. The outer legs are more upright and travel

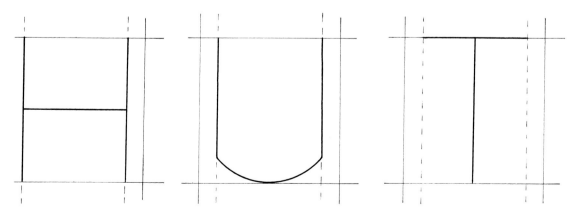

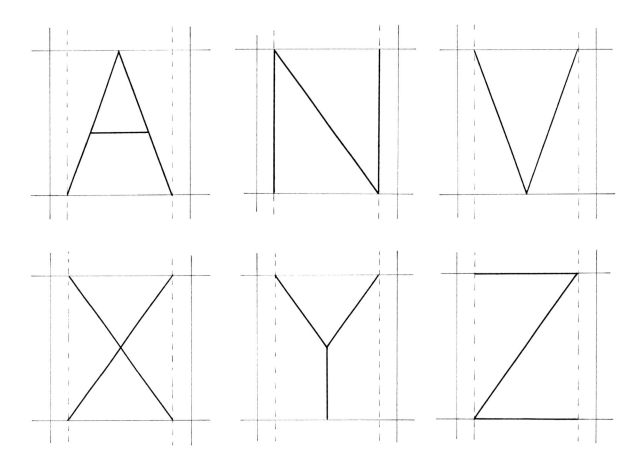

diagonally from the top corner of the rectangle to the bottom corner of the square.

- To make W, draw two Vs side by side. This gives you a total width

of two rectangles, or one and a half squares.

Note: W really is a very wide letter; M is not an upside down W.

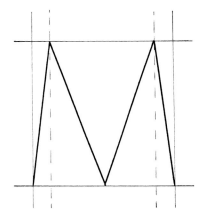

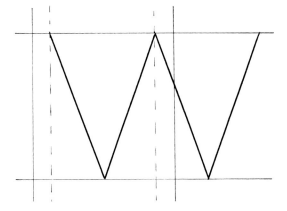

The Narrow Letters are
B P R L E F I J K S

They are approximately half the width of the square. Here the geometry becomes a little more complicated and a little less precise. Most of these letters are visually complex and are divided vertically near the halfway point. This waist creates a top and a bottom, each of which relates to the circle. The basic grid diagram therefore needs a little adaptation.

To the basic circle/square/rectangle are added two further squares. The top square is a little smaller than one quarter of the original square, the bottom square a little larger but each is a perfect square. This allows for the construction of the waisted letters.

The centre of the diagram is marked by the dot.

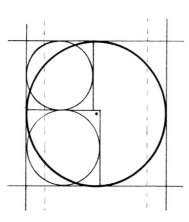

◆ The vertical stroke of L, E and F bisects the area between the edge of the rectangle and the edge of the square.

◆ The vertical stroke of K moves to the side of the square. The diagonal strokes need a slightly wider shape to create a good balance of white. They meet in a right angle against the stem.

◆ Add circles to the two contained small squares. The vertical strokes bisect the area between rectangle and square as in L. The bowl of P and R follows the top circle, the bowls of B follow the upper and lower circle. The balance between the upper and lower parts of these forms needs careful attention when they become letters.

◆ To construct S and J, move your small circles to the right side of your basic grid structure. S follows the two circles round in a continuous curve, but again the slightly larger base is important to the balance of the shape.

◆ I is simply a straight line. J, which is not a Roman letter, is usually I with a curve at its base following

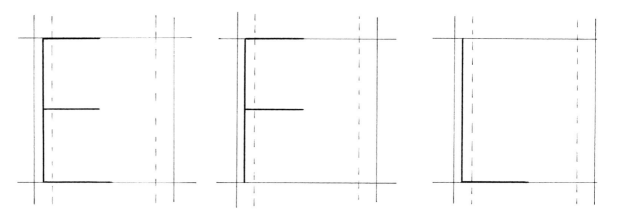

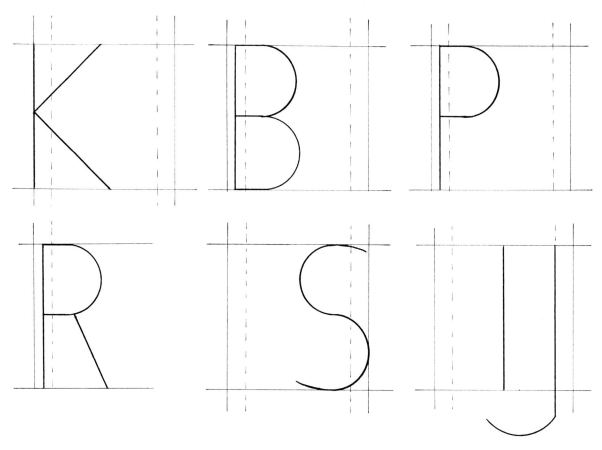

the lower circle. This curve may drop below the writing line.

This is as close as we can get to drawing the idea of letters. These forms have little visual appeal, no subtleties and no life, but they do give the essential form and the related proportions of Roman majuscule letters.

Skeleton Capitals

The next stage is to take these precise but dead marks and give them life. Any monoline tool with which you feel comfortable is appropriate, such as a soft or coloured pencil, a drawing pen or a very narrow-edged pen. If you practise writing the letters in their related groups, you will see that, as with minuscule letters, you

are repeating marks and movements. Learning the relative proportions of the letters at this stage will be invaluable when you come to write pen-made letters. Try to bear the following points in mind as you practise making these letters:

Practise the letters in their related groups.

 ◈ Make them large enough so that you can really see what you are writing. 20mm (¾in) high is a reasonable starting point.

 ◈ Write O every so often to check that all your other letters relate correctly to it.

 ◈ Make the letters with a sequence of direct strokes just as if you were handling a pen.

Do not expect it to be easy.
It takes skill to handle these letter forms confidently, but the exercise is worthwhile because you are absorbing very important ideas and understanding. You may find in time that you begin to enjoy the letters and that possible uses in pieces of work will begin to suggest themselves.

Do not simply reproduce the geometric forms.
You are now moving on to writing and so a few subtleties and refinements should be allowed.

◆ Make sure that you are making D wide and round enough.

◆ Relax the tail of Q a little.

◆ Drop the crossbar of A a little to create a pleasing balance within the letter and try making A

minimally wider than H at its widest point.

◆ Curve the sides of U smoothly into the base.

◆ Increase the width of the base of Z to give the letter more stability.

◆ If you are having trouble with M, try writing the centre V and then adding the legs. When you have fixed the image in your mind, you can go on to write the letter properly in four strokes from left to right.

◆ Remember that W is very wide.

◆ Watch the relationship between the horizontal strokes of L, E and F. L and E will look more stable if the base stroke is a little wider than

the upper strokes – but it should be a minimal difference.

- The bowl of P will also look better if it is just a little larger than the bowls of B and R.

- Allow the leg of R to relax, but only a little.

- S needs to become a continuous curve.

Spacing

It is possible to analyse the good spacing of geometrically made letters, which will be a useful foundation for working with pen-made letters in due course.

PEN-MADE ROMAN CAPITALS

Most majuscule letters are constructed in a more deliberate fashion than minuscule scripts. The accepted forms of a minuscule script are usually developed in part from the movement of the hand and the quill or pen. With Roman capitals the form comes first and the pen and hand learn to move so that an acceptable likeness can be made. However, when these letters are written with a pen, they should still be written as rhythmically as possible and with direct firm strokes to give them life.

The Character and Uses of Pen-Made Capitals

These are essentially important letters. At their best, they have a dignity and authority which relate to their monumental

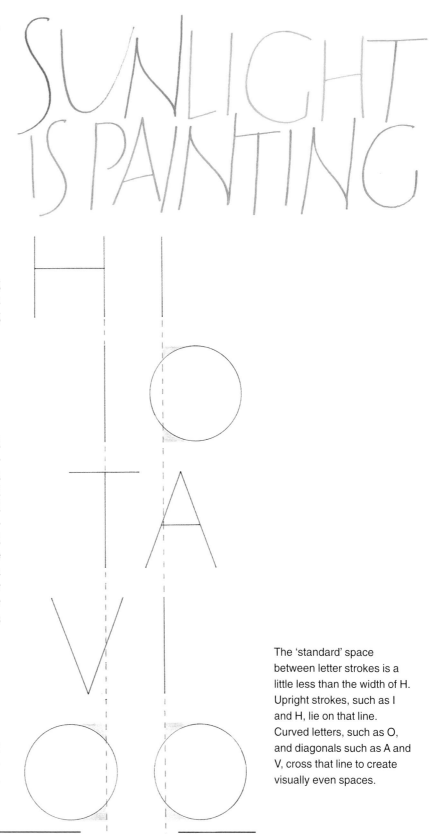

The 'standard' space between letter strokes is a little less than the width of H. Upright strokes, such as I and H, lie on that line. Curved letters, such as O, and diagonals such as A and V, cross that line to create visually even spaces.

Classical cousins. Because the underlying form is a circle, they sit happily with Foundational hand but historically they were used, in drawn or pen-made form, with a great range of scripts.

Most calligraphers find that it takes a while to get to grips with capitals. The letters demand careful study and time, and you will probably only want to use them for punctuation, such as marking the opening of a sentence or for names, or as a simple heading at first. However, it is worth taking time to master them. Poorly written capitals will spoil an otherwise capable piece of writing. Once they are secure in your mind, you will find them easily adaptable and very versatile.

Weight, Angle and Form

Begin your studies with a large nib and guidelines at seven nib widths apart. When you use the letters as occasional capitals in a piece of text you will realize that this weight may need to be changed to make the capital sit well against its minuscule neighbours.

The basic pen angle is 30 degrees, another reason why these letters relate well to Foundational hand. The pen angle is altered for letters containing diagonal strokes so that an elegant balance of thick and thin lines can be maintained.

The underlying form is the circle and the related rectangle.

Letter Groups

Majuscule letters are made from a series of pen strokes, exactly like minuscule letters. Always pull the pen from top to bottom and from left to right if possible. Certain basic strokes are common to each letter group.

ROUND LETTERS

◈ The pen angle is 30 degrees.

◈ O is made from two strokes, exactly as a Foundational o is made, but larger.

◈ The first stroke of O, a half-circle curve, is repeated in Q, C and G.

◈ The stroke completing the top of C and G is a very shallow curve so that it points the eye forwards. Curve it round too much and it makes the letters look downcast and unstable.

◈ The tail of Q emerges from the thinnest point of the circle; allow it to relax a little, but not too much.

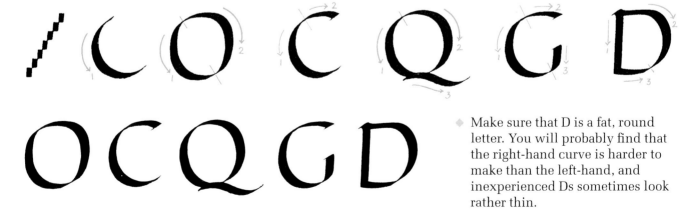

◈ Make sure that D is a fat, round letter. You will probably find that the right-hand curve is harder to make than the left-hand, and inexperienced Ds sometimes look rather thin.

RECTANGULAR LETTERS

These letters are made up of straight lines except for the base of U. Use the same rounded serifs which were used for the Foundational hand.

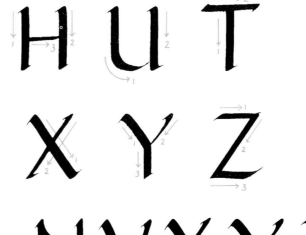

- H, U and T are made with a pen angle of 30 degrees.

- You may find that flattening the pen angle a little for the crossbar of H makes a more elegant letter.

- The pen angle must be steepened to about 40 degrees for A, V, X, Y, and N. However, a consistent steeper pen angle won't work. Look carefully at what is happening under your pen and change the pen angle for each stroke until the visual balance is right.

- The crossbar of A probably needs a flatter pen angle, as in H. Make sure that the crossbar divides the internal white space at a visually attractive point.

- Make sure that diagonals which pull from the right down to the left, as in A, V, X and Y, are not too thin.

- The top and base of Z are written with a 30 degree pen angle. The right to left diagonal should be written with a flatter pen angle so that the letter has body.

WIDE LETTERS

- M is a V to which two almost upright outer legs have been attached. To achieve the balance of thick and thin strokes, the pen must begin at a steep angle, turning to a flatter angle for the fourth stroke. Note that the centre V creates a significantly larger white space than the other two counter triangles.

- W is two Vs side by side; it really is a very large letter.

With both these letters, and with others containing diagonal strokes, you will

find in time that some of the strokes become very gently curved. This is a natural development as you begin to write more confidently and easily. However, it is better to wait for this movement to happen naturally. Begin by making the strokes as strong and straight as possible. Imposed curves from an inexperienced pen tend to look weak and loose.

NARROW LETTERS

- Historically, I has no top or tail stroke and J is simply a variant of I.

- B, P and R are made using the same strokes. Because P has no

slightly longer than the two upper strokes – but only just.

- The lower horizontal of F is slightly shorter than the top – but again only just. Pull the first stroke of S diagonally down to make it a tall, thin letter.

HOW TO PRACTISE

Look back at the notes on Foundational hand practice. Those hints apply to the study of any formal calligraphic script. When learning capital letters, it is particularly important to become completely familiar with the related proportions of the letters. Letters should be practised in their related groups; keep checking that they really do relate within their groups, and practise every letter against O. It is important to keep checking your pen

base, the bowl can be slightly larger than that of R and B, but keep the difference minimal.

- Allow the leg of R to relax if there is room in the word you are writing but keep it under control. The same is true of K.

- E is made exactly like L with two extra horizontals. The base of E is

angle, particularly when you are working on the rectangular letters.

One of the most frequent weaknesses in inexpert majuscules is messy joins. If you overlap the strokes when making a letter, the form will have greater strength and a pleasing unity.

If you are also learning to look at the white counters, you will realize that part of the visual firmness of the letter comes from the clean inside shapes with their

NEAT

crisp corners. Well-made capitals come from positive direct strokes, clean overlapping joins and crisp inside white shapes.

NUMERALS AND PUNCTUATION

Numerals

This is only relevant for texts written entirely in capitals. In other contexts, be guided by the minuscule forms. As with minuscules, the capital zero echoes the form of O. Numerals are written to the same uniform height as the letters. The pen angle is 30 degrees and the weight of the numerals is seven nib widths high. These points about particular numbers should be noted:

- The serifs on 1 and 4 are made by lifting the pen and making an additional stroke to add formality.

Punctuation Marks

Again, this is only relevant for texts written entirely in majuscules. If punctuation marks are necessary, keep them in character and as minimal as possible. The pen angle is 30 degrees and the marks sit within the guidelines.

The most visually successful full stop is drawn with the pen at 45 degrees halfway between the top and bottom guideline. This echoes the incised mark used in Classical inscriptions and makes a decorative as well as a functional feature.

I suggest that you always consider whether a text written entirely in majuscules really needs punctuation marks. Capitals usually take longer to read than minuscules and a well-constructed text, slowly read, may be perfectly understood without these visual promptings.

SPACING

Letter Spacing

The spacing of pen-made majuscules follows the principles outlined for skeleton capitals. The white counter spaces echo the spaces between the letters, creating an even pattern of black and white

1 2 3 4 5 6 7 8 9 0

- The bowls of 3, 5, 6 and 9 should echo each other and the roundness underlying the letters.

CAPITAL LETTERS

across the page. However, because your letters now have weight, the marks are more complex and subtle than the skeleton letters and the judgment of your eye becomes more important.

To check the evenness of your spacing:

◆ Turn the writing upside down and look at the pattern.

◆ Pin your work, upside down, on the wall and stand well back.

Both of these methods prevent you from reading the letters, forcing you to look at the shapes and marks that you are making.

◆ Look for white holes and for dense black areas.

◆ Look at the letters in a piece of writing in groups of three. Take two pieces of card and cover letter four onwards. Look at letters one to three and evaluate the spaces inside and outside the letters. Now use your cards to cover letter one and letter five onwards. Look at letters two to four in isolation. Move along your text in this way and your eye will learn to see irregularities in the spacing.

Word Spacing

The space between words is only slightly larger than that between letters. Too much space between words creates visual breaks which disrupt the visual texture of the writing. Imagine that you are writing blocks of even knitting.

DIFFICILE EST SATURAM NON SCRIBERE

6 Italic Writing

The term italic can pose problems. To many printers and others working with typography, it is simply a catch-all to describe any letters which slope forwards. To many non-calligraphers, it means an everyday but elegant handwriting, and for the calligrapher it describes a very wide range of formal and informal scripts.

The italic script has its roots in the Italian Renaissance and was probably first developed in the late fourteenth century. From the beginning close links between printing, formal calligraphy and handwriting were evident. *La Operina*, the first writing manual published in Europe in 1522 by Ludovico degli Arrighi, a professional scribe employed in the Papal Chancery, featured an italic script, and an italic typeface was designed and used by Aldus Manutius in Venice in 1501. A form of italic was developed and adopted for use in the Papal Chancery round about 1450 for the writing of Papal briefs and informal documents. The hand was useful because it was clear and legible and it could be written quickly, helping to accommodate the increasingly heavy flow of administrative documents.

AN ITALIC MODEL

The diversity of italic writing means that the contemporary calligrapher, wanting to make a study of the writing, must

A page from Bembo's Italian sonnets, written in Italy around 1543. Victoria and Albert Museum, MS L1347 – 1957. Page size 215 × 140mm (8½ × 5½in).

S ignor, che parti et tempri gli elementi,

E'l sole et l altre stelle 'el mondo reggi

E t hor col freno tuo santo correggi

Detail of Bembo's Italian sonnets.

choose a specific manuscript as a starting point. The model used for this study is a book of sonnets, manuscript number MS L1347 – 1957, which is in the Victoria and Albert Museum in London. The sonnets were written in Italian by Pietro Bembo, and were then written out as a book for Lisabetta Quirini in about 1543 by at least two anonymous scribes. The writing of the original scribe, who produced the first sixty-three folios, is the model here.

This particular manuscript makes a good starting point for a study of formal italic for the following reasons:

◈ It is written with great skill and authority.

◈ It is clear and easily read.

◈ It lacks personal idiosyncrasies or decorations.

◈ The letters are formally constructed and stand separately without ligatures.

Once you have a controlled, formal italic script in your calligraphic repertoire, there are many other Renaissance manuscripts and contemporary examples of distinctive and beautifully developed italic writing which are well worth studying.

The Character and Uses of the Hand

The essence of italic writing is the flowing, rhythmic movement with which the letters are made. The script is usually written quite quickly with fewer pen lifts than are necessary for the more deliberate construction of Foundational hand. Because of the speed, the writing frequently becomes cursive and the letters can become pointed and sometimes rather aggressive. The writing of the Bembo sonnets is very controlled and so keeps a softer character with separate, self-contained letters. It is also tiny, as is most Renaissance italic. However, the versatility of the script means that it can be adapted to work well at almost any size and although it is probably more comfortable at a smaller scale, it can successfully be written very large.

Even at its most formal and disciplined, italic writing possesses vitality and a certain decorative quality. It can be very lively and personal, lending itself to flourishes and other extravagances, but if it is used for writing large blocks of text,

the script and the design must be carefully controlled and arranged in the interests of legibility. Too much decoration and energy can lead to visual exhaustion.

Italic usually has a contemporary look and feel, which may be why the uninformed sometimes dismiss it as too easy and too uninteresting; after all, 'real calligraphy' looks strange and old and is difficult to read. It adapts to the sensitivities demanded by a piece of poetry or the robustness of a greetings card or a jampot label. It can look fragile and delicate or tough and aggressive. It almost always has an intimate quality. It is not easy to master, but you can't live without it.

ANGLE, WEIGHT AND FORM

The pen angle for these letters is about 40 degrees. The weight is five nib widths high. The underlying shape of the letters is oval. This is why italic, although an essential hand for a modern calligrapher, is not the best hand with which to begin. An oval is not an absolute form and the calligrapher must choose his or her version of the oval on which to base the rest of the alphabet. Tagliente, the Venetian writing master working at the end of the fifteenth century, recommended an oblong five nib widths high and three and one-third wide as the basis of all italic letters. That may be a bit tricky to work out, but the proportions are a good basis for a pleasing alphabet.

The 'rules' for italic are logical. The hand has its origins in the Papal offices where documents had to be written quickly and clearly. It was developing at a time when printing was just beginning to be a significant influence, taking over the role of the scribe who produced books by hand. In this new world, calligraphy had to change.

If you hold your pen at a steeper angle, you can write faster. There is less friction between pen and page, the nib moves

more freely, more quickly and does not have to be lifted from the page too often. What will then follow is that your letters become taller and narrower, having a lighter weight and a more oval shape.

PATTERN

Almost more than for any other classic formal script, regular pattern underlies and informs italic writing. The letter

shapes grow out of a few simple movements, giving the hand a visual regularity and uniformity which, when analysed, seem almost dull after the variety of Foundational hand. However, although simple patterns are easy to grasp intellectually, they are not easy to reproduce on the page. The hand takes time to learn. To understand the pattern of formal italic writing, your eye must appreciate the even, repeated marks of the pattern and your eye the controlled,

To learn the regular movements which make the patterns of italic writing, it is best to work within ruled guidelines. Use a large nib – a 1 or 1½ Rexel nib, and work between guidelines which are five nib widths apart. You will need to get used to holding your pen at an angle of about 40 degrees.

Essentially, italic letters are based on two patterns; try a few variations to feel the difference. You will notice that the speed and the rhythm of your hand change with each different shape.

regular movements particular to the script. If you begin by making the simplest repeated patterns, using square-cut felt tips or fountain pens if you wish, you will understand just how difficult this absolute regularity is to achieve.

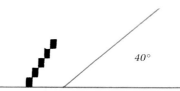

This is a useful exercise because you will discover visual ideas for simple decorations to add to your calligraphic work. But, more importantly, if your patterns are to be regular, you must look at the white spaces just as much as at the coloured marks. The eye is attracted to the coloured shapes, but it also sees the white channels and the shapes they make.

To write a strong formal italic:

◆ Practise making gently rounded arch shapes.

◆ Be very aware of the feel of what you are doing.

◆ Try to keep an even, measured pace.

The two patterns that underlie italic writing.

Variations on the above patterns.

- Try to make the white inside shapes as even as possible.

- Check that your pen angle really is 40 degrees. For the beginner who has studied only Foundational hand minuscules, learning the feel of a new pen angle can take time.

- Try to touch the guidelines with each shape.

Your patterns are unlikely to be completely regular; the important element of the exercise is for your hand and eye to learn to be as precise as possible.

THE SLOPE OF THE WRITING

A practised italic hand has a forward slope, but so do most minuscule scripts when written with confidence and understanding. If you look at the work of skilled contemporary scribes, you will find examples of Roman capitals, Foundational hand, italics and many other scripts all sloping forwards. As with everyday handwriting, the slope develops because the writing is rhythmic and practised.

Different calligraphy teachers have different ideas about the emphasis to be placed on learning to slope your italic writing. Some consider that a slope should be imposed upon the letters from the very beginning and some suggest ruling guidelines diagonally across the page at 5 degrees from the vertical so that you have a 'slope grid'. I suggest that, at the beginning, you forget about the slope.

When you first learn and practise the letter shapes, make them upright, or leaning very slightly if that comes naturally to you. Gradually, as your letters begin to develop into writing, you will find that a slope also begins to develop. When your writing is ready to slope, it

will. You may then need to pay some attention to the slope:

- Letters which slope should do so evenly so that strokes are parallel with each other.

- The slope must be forwards.

- A slope of about 5 degrees to the vertical is plenty for a formal italic.

- Too steep a slope will make your writing illegible.

Letter Groups

FOR THIS ALPHABET:

- o defines the proportions of the letters.

- a and n define the particular character of the writing.

- i defines the serifs.

To write letters at this fairly large scale you will need to lift the pen more frequently than is necessary for smaller,

writing *nearly illegible*

When your writing begins to slope naturally, the slope will wobble and it will take a while to settle and become regular. Don't be impatient. Irregularities in the slope of your writing may be useful clues of weaknesses. Are you slowing down at that point, writing too quickly or perhaps leaning to the right instead of moving your paper? Or maybe you are hesitating over your least favourite letter?

more cursive or informal versions of italic.

The first stroke is the first half of the oval shape which underlies all the letters. Begin just below the top guideline where the pen stroke is at its thinnest, just as you did for Foundational hand. Pull round and down to make a half oval.

To make the second stroke, put your pen back into the wet ink at the top of the

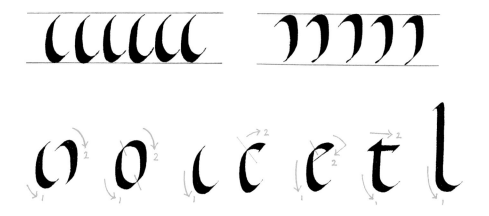

stroke, pull up to the guideline, round and down and into the base of the first stroke. Complete o, c and e in this way.

The letters o, c and e should have very gently curved sides. However, you may find it easier initially to think of them as straight sided. The marks will relax into softer shapes with experience.

For t and l, the first stroke is slightly adapted and must be straight. The letter t is sometimes extended above the top line, which is visually acceptable because of the up-down pull of the script.

Make sure that these five letters have good curved bases on which to stand. This is important to the pattern of the writing and to the stability of these letters.

The third stroke defines the serif and gives i.

As the pen angle is steeper and the movement faster than for Foundational hand, the serifs will probably be larger and sharper, but don't allow them to become exaggerated and spiky. For a formal hand, every element of the writing should be controlled and contained.

To write j, keep the pen on the paper and push round to the left. For the dot, move the pen lightly on the paper from right to left and lift off.

The fourth and fifth strokes define the most characteristic marks of italic and are evident in the two basic patterns studied earlier.

The fourth stroke gives the a group of letters. Begin as for the first stroke of o, pull down to the guideline and at the line the stroke turns quite sharply and rises just as if it were returning to the top guideline. To complete a, return the pen to the beginning of the first stroke, pull to the right, turn sharply and drop down to the baseline.

Again, a, g, d and q should have very gently curved stomachs and straight backs, but it may be easier at first to make them with straight, parallel backs

The 'o' group of letters.

The 'i' group of letters.

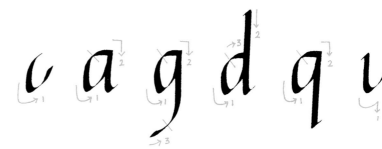

and fronts. The letter u needs two straight sides.

Note that the top right-hand corner of a, g and q should be clean and sharp.

The tail of g will probably push to the left, but if you find that difficult, lift your pen and make a third stroke. Keep the curve of the tail shallow to echo the shape of the bowl of g.

The 'a' group of letters.

$a g d q u$

The fifth stroke gives n and the arched letters and is very similar to a upside down.

It should be possible to make n in one stroke. The branching arch of n, which grows out of the steep pen angle and the forwards movement of the hand, creates the distinctive white triangle also evident in the a group of letters, which is a visual characteristic of italic.

Look at the inside white counter of n and the other arched letters and try to keep it softly rounded. You are training your hand to move smoothly, making a continuous movement to produce the elegant shapes that formal italic demands. Left to its own devices, your hand will begin to make broken staccato movements because they are easier, and as a result your letters will become spiky and aggressive.

If you find it difficult at this scale to make h or m in one stroke, stop, lift the pen and make two or more strokes. Ease will come with practice.

The letter r can be made in one stroke; b is exactly like h but with the base of the arch pulled round to the left.

It is probably expecting too much at this size to make the stem and bowl of p in only one stroke. To make the bowl, put the pen back low into the down stem so that you are picking up plenty of wet ink and keeping the movement flowing.

On the other hand, k can be made in one stroke with an enclosed bowl, although if you prefer the lighter look of the open counter, you should use two strokes.

The sixth stroke is the diagonal used in v, w, x, y and z. At a small scale you will probably find that you can push the pen enough to write v, w and z without lifting it from the paper. At this larger scale make all the strokes separately by

The 'n' group of letters.

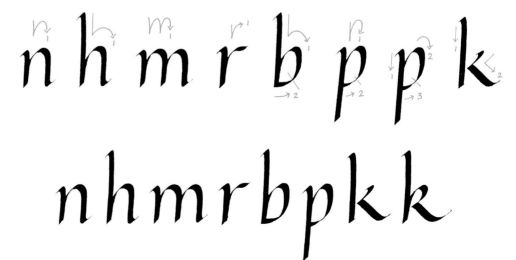

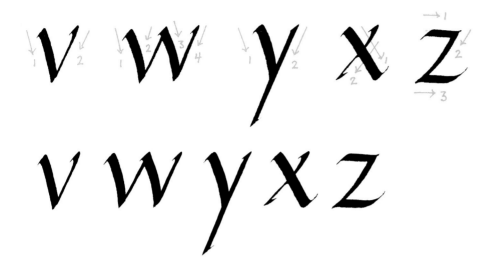

The diagonal group of letters.

pulling down from the top guideline. This also gives you the opportunity to change the pen angle if a little subtle variation is appropriate.

The diagonal letters all relate to the dimensions of the o and at their widest echo the widest point of o.

This leaves s and f, which do not really fit into any of the related groups.

An s is made in three strokes, just as the Foundational s. Think of it sitting on top of the oval o and echoing the width. The first stroke should have quite a strong diagonal pull to give the letter its long, slim structure. Keep the top and the base curves very shallow and contained by the width of the letter so that it is balanced.

The letter f can be made in two different ways. Each version has a distinct personality and so your choice depends on the context in which you are using the letter as well as your personal taste.

The more restrained f which sits on the lower guideline is probably the more useful, as it neither draws the eye nor creates problems by colliding with lines above and below. However, the more flamboyant f has a sound historical pedigree and can look very elegant. If you are using it in a block of text, keep it reasonably contained unless you are deliberately

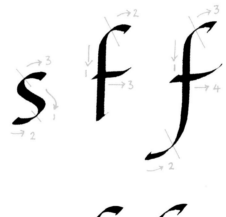

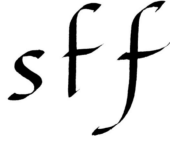

extending and exaggerating it to make a decorative feature.

Ascenders and Descenders

For a formal italic, ascenders and descenders need to be about equal in length to

the body height of the letters; shorter than this and the script will begin to lose some of its grace, whereas longer strokes will compromise the formality. Be careful, as you become more confident and sure of your writing, that your ascenders and descenders don't become overgrown and begin to look straggly and limp.

However, because of the vertical movements which make italic, the script lends itself to flourished ascenders and descenders. At its best, a flourish is an extension of the natural writing movement.

Ascenders must be flourished more deliberately.

Simple decoration can be added to ascenders and descenders by 'adapting' endings and serifs.

A good flourish looks easy and graceful but it's not easy to do. Be prepared to

practise and don't try to be too clever too quickly. Do not be tempted into covering all your writing with flourishes and elongated fs and gs because it feels nice to do them (which it does). Decoration should be used with discrimination. A little goes a long way.

HOW TO PRACTISE

Look back at the notes for practising Foundational hand. That advice is just as relevant to italic studies.

mmombnemojnam

uucuguahuoueuuc

Because the movement is so important to italic, check:

- that you are sitting well;

- that you are balanced, comfortable and relaxed;

- that you really are moving your whole arm;

- that you are not gripping your pen too fiercely;

- that you are breathing easily.

When you are first learning the letters:

- Learn and practise them in related groups.

- Every so often, go back to the basic patterns to check the movement of your arm and hand.

- Try making a row of pattern and incorporating a few letters. Don't break the rhythm if at all possible.

NUMERALS AND PUNCTUATION

Numerals

As with other scripts, numerals echo the weight, angle and form of the minuscules. It is important that the oval of zero echoes the proportions of the oval that you have chosen for your letters.

Numerals are five nib widths high and written with a pen angle of about 40 degrees. If you write them with the same rhythm used for the written letters you will find that visual similarities occur.

The widths of the numerals, as with the letters, should be uniform and, because the script is quite tall and compressed,

1 2 3 4 5 6 7 8 9 0

the numerals should echo that image. Numbers 3 and 5 repeat a stroke for the bowl and 6 and 9 are almost reverse images.

Punctuation

If you keep your hand and arm movement consistent, punctuation marking will look light and appropriately lively.

As with ascenders and descenders, there may be occasions when a question mark can become a decoration if made with a flourishing movement.

SPACING

Letter Spacing

Most scripts have a natural scale. Renaissance italic hands were usually written small, but one of the great strengths of italic writing is that it can be written very small or very large and still look good. This versatility means that defining good spacing is almost impossible. Very small writing, as in the Bembo sonnets manuscript, needs generous spacing so that legibility and an image of formality and control can be preserved. However, if you enlarge a piece of very small writing step by step on a photocopier you will see that gradually the spaces become too large, legibility breaks down and eventually the writing falls apart and becomes a string of letters. This is a consideration if you are preparing work which is to be reduced or enlarged for printing. The letter shapes may adapt happily, but the spaces are likely to need some adjustment.

As you are working with a large nib and a formal italic hand, begin by looking at the pattern exercise under 'How to practise'. The spaces inside letters are more or less uniform because of the regular pattern movement of the hand. If the hand is moving evenly, the space between the letters will echo the space inside the letters.

Word Spacing

The proper space between words again will depend on the scale of the writing and its character. For a formal italic hand, the spaces between words should be just a little wider than the spaces between letters. This will be sufficient to inform the eye without breaking the rhythm of the script.

pattern of writing

7 Related Capitals

The early Renaissance writing masters used Roman capitals with their italic scripts, sometime carefully and formally made and sometimes written with a free and experimental approach that led to the creation of some shapes that were exuberant and quirky, and to some that were ill-conceived and ugly. It is salutary to remember that a manuscript may be old but the writing is not necessarily skilled or worth using as a model. It was only later that capital letters were compressed to make them compatible with the oval shape of italic minuscules. There is no generally recognized historical model for italic capitals and you will find significant variations both in historical and contemporary uses and interpretations.

The most important criterion is that your capitals sit happily against your italic minuscules. This is particularly relevant if you are using the occasional initial capital for a name or the start of a sentence. If you are writing a piece of text entirely in italic capitals you have much more freedom to experiment with the degree of compression in your letters so that you can control the texture of the calligraphic picture which you are making.

Freely adapted italic capitals.

CONSTRUCTING ITALIC CAPITALS

First, make sure that you are familiar with the proportion and construction of Roman capitals. Italic capitals are constructed in the same related groups using a similar sequence of strokes.

Angle, Weight and Form

This version of italic capitals is written at eight nib widths high, which gives a tall, slender letter. However, the height of the occasional capital within a block of minuscule text always has to be adjusted so that the letter looks as though it belongs to its surrounding neighbours.

The pen angle of my letters is a little flatter than 40 degrees, but it is steepened quite significantly for the diagonal strokes. The underlying shape is an oval.

Letter Groups

The O group is O C G Q D

Begin by choosing an O which relates to your minuscule italic o. The other letters in the group repeat these proportions and, except for D, repeat the same first stroke.

The H group is H T U A N V X Y Z

Because my O is quite a narrow oval, the letters in this group are almost as wide as O.

The letters which include diagonal strokes are written with a steeper pen angle which varies from letter to letter. N, for example, is written with a pen angle steeper than 50 degrees.

It is important to keep looking at the letters you are making. I have chosen a tall, slender look for my alphabet so all the letters must comply with this.

The B group is B P R K L E F S

The letters in the B group are about three-quarters the width of O. The bowls of B, P and R relate to each other and to the oval O, but make sure that the curves are wide enough for the letters to look balanced and attractive.

If the waists of B, P and R and K just touch the stem, this will allow a little light into the letters. The shapes should remain elegant and carefully finished.

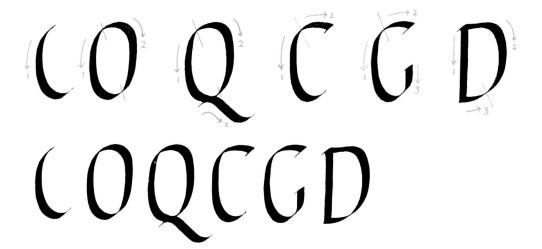

The 'O' group of letters.

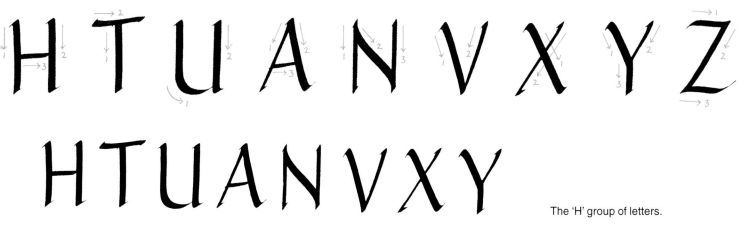

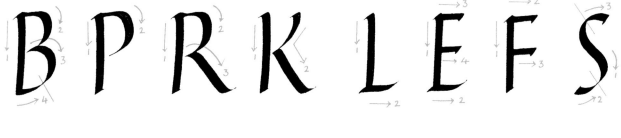

The 'H' group of letters.

The 'B' group of letters.

The remaining letters are I J M W

I and J are made just like Roman capitals. M and W are wider than O. The centre of M and each side of W are as wide as V. Turn the pen to steeper angles for the diagonal strokes.

The first three strokes of M are written with a steep pen angle that is flattened for the fourth stroke.

HOW TO PRACTISE

Look back at the notes for practising Foundational hand and Roman capitals.

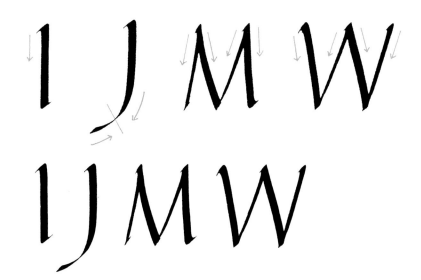

These italic capitals are not based on a particular model but rather on the idea of compressing an accepted pen-made form of Roman capital to serve a particular purpose. So, as italic capitals are built on shifting sand, why not use this flexibility in your practice?

Try the following:

◆ Invent Os of different proportions – fat oval, very slim, short, or long – then devising the rest of an italic alphabet, capitals and minuscule, to go with each O.

◆ Vary the weights of your letters – rule guidelines at five, seven, ten and twelve nib widths high.

◆ Write skeleton italic capitals.

◆ Write words with your favourite nib but without any guidelines.

◆ Write words in capitals but trying to keep the movement of the minuscule italic script.

widths high. The pen angle is a little flatter than 40 degrees and zero echoes the oval of your letter O.

Make sure that the bowls of 3, 5, 6, 8 and 9 echo the oval. Numerals sit with letters and the proportions of each should match. Use your letter O, its width and height, as the starting point for zero.

Punctuation Marks

As with Roman capitals:

◆ Consider whether punctuation marks are really necessary.

◆ Keep marks in character and contained within the height of the letter.

◆ Keep marks to a minimum.

As with italic minuscules:

◆ Try to keep the writing movement consistent so that markings look lightly made.

◆ Keep a pen angle of about 40 degrees.

NUMERALS AND PUNCTUATION

1 2 3 4 5 6 7 8 9 0

Numerals

These are only relevant if your text is written entirely in majuscules. If this is not the case, follow the guidelines for minuscule numbers.

Numerals for capitals should be of a uniform height – in this case, eight nib

Try making a lozenge with the pen at 45 degrees midway between the guidelines instead of writing a full stop. This may look too formal and monumental for some italic capitals, or it may look just right. Try it and see.

SPACING

Letter Spacing

As with all formal writing, you are aiming to achieve an even balance of black marks and white spaces along the line. Look back at the notes for spacing Roman capitals. Remember:

◈ Italic capitals are compressed. The space around the letters will echo this tighter space inside the letters.

Allow the rhythm of your hand to help the spacing.

Word Spacing

Generally, the space between words should be about the width of O. However, this is only a starting point and adjustments need to be made according to the shape, weight, height and scale of your letters. There are no absolutes. Look at what is happening beneath your pen:

◈ Are you creating an even texture?

◈ Is your text legible?

◈ Does the eye run quickly along the line without hesitation or interruption?

THE STARS IN ICICLES ARISE

◈ Italic capitals are much more uniform than Roman capitals, so spacing will be uniform and consequently easier to accomplish.

◈ Confident italic capitals should be written with the same life and movement as the minuscule script.

◈ If you look at your writing upside down, does it look even? Are there 'holes' of white or dense areas of black?

It takes time to learn to judge, and that skill can only be gained by doing, thinking and looking.

Dixit autem eis ihs

ego sum panis uitae

qui ueniet ad me non esuriet

et qui credit in me

non sitiet um quam

poc
funct

Sed dixi uobis quia et uidistis me

et non credidistis

Omne quod dat mihi pater

ad me ueniet

Et eum qui uenit ad me

non eiciam foras

Quia descendi de caelo non

ut faciam uoluntatem meam

sed uoluntatem eius

qui misit me

Haec est autem uoluntas eiy

qui misit me patris

ut omne quod dedit mihi

non perdam ex eo

8 Uncials

Uncial writing has very deep historical roots. It was in use as a bookhand from the third century and the script was developing and becoming widely used at the same time as the codex, that is a book with a page structure, was beginning to supplant the scroll. Uncials were widely used over a period of several centuries and the script developed many forms. It is impossible to speak of 'the' uncial hand.

Early uncial hands may be the earliest Western calligraphic scripts developed because of what the pen and hand could do rather than being adaptations of incised or painted capital forms. Whatever the palaeographic truth may be, early uncials seem to have been made simply, using direct pen strokes and with the pen held at a reasonably natural and comfortable angle, but eventually forms of the script developed that could only be made by twisting and turning the pen to make different strokes. These manipulations and contrivances meant that the writing looked impressive and sophisticated but producing it was slow and very skilled work.

AN UNCIAL MODEL

The model used for the study in this book is the St Cuthbert Gospel, also known as the Stonyhurst Gospel and currently on loan to the British Library. It is a remarkable book in many ways.

This copy of the Gospel of St John in Latin was written sometime before the death of St Cuthbert in AD716 probably in Bede's community of Wearmouth–Jarrow. We can date it so accurately because it was found in the coffin of St Cuthbert when his relics were removed to their new resting place in Durham Cathedral in 1104. The book is still bound in crimson goatskin and is the earliest known European binding that still protects the manuscript for which it was made.

The page size is 137 × 92mm (5⅖ × 3⅜in), which is tiny, and the writing is therefore small but it is very strong and clear. It is simple and undecorated and written with a fairly consistent pen angle suggesting a relatively rapid construction. The book has the feel of a real volume meant to be handled and used, perhaps slipped into a pocket.

The Character and Uses of the Hand

Uncials are usually considered to be majuscule forms, but in fact they are capitals which are developing tendencies towards the minuscule. Although most of the letters are of a uniform height, there are occasional diversions into ascenders and descenders but these are always kept very short. The look of these uncials is of solid, round forms. The letters have a strength and vigour because they are made with direct pen strokes using a comfortable pen angle and they are written with rhythm.

Uncials are an important calligraphic study because of their significance in the history and development of formal writing. The St Cuthbert Gospel writing combines dignity and presence with vigour and charm, and although written with a quill on vellum, the script presents few

(Facing page)
A page from the St Cuthbert Gospel, written sometime before AD 716. Page size 137 × 92mm (5⅖ × 3⅜in). Loaned to the British Library by the British Province of the Society of Jesus.

> qui misit me
> Haec est autem uolunt...
> qui misit me patris
> utomne quod dedit mihi
> non perdam exeo

The St Cuthbert Gospel, detail.

problems of adaptation for the contemporary calligrapher working with modern tools and materials. However, uncials do have an archaic look and their uses are limited.

From its earliest development uncial writing was associated with Christianity and it is interesting that the connection with the organized Christian church continues. You are more likely to encounter uncials on Christmas cards or on text sheets in the cathedral bookshop than on advertising hoardings.

ANGLE, WEIGHT AND FORM

The pen angle needs to be quite flat – about 15 degrees. I suggest that you begin with letters four nib widths high, although when you are more experienced you might like to try three and a half or three nib widths high to emphasize the sturdy solidity of the letters. The underlying form of the letters is a circle but you will realize that the balance of weight within a letter o caused by the

flat pen angle makes the i slightly wider than it is tall. If you then reduce the weight of the letters to three and a half or three nib widths high, this sideways pull will be emphasized.

A Foundational o, because of the 30-degree pen angle and a weight of four nib widths, sits four square. The taller compressed italic o, written at a steeper pen angle, has a decided vertical pull. The flatter pen angle of an uncial o gives it a slightly horizontal pull at four nib widths which is emphasized at three and a half or three nib widths high.

THE PATTERN

Begin by getting used to the feel of a flatter pen angle when writing with a large nib. Rule some guidelines at four nib widths high and try the marks shown below.

The pattern of these particular uncials is simple, using round letters, straight letters, diagonal strokes and arches. You won't find the shapes difficult to learn but:

- ◆ Do check your pen angle frequently.

- ◆ Try to learn the feel of working with your nib at 15 degrees.

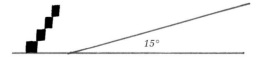

15°

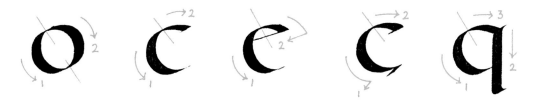

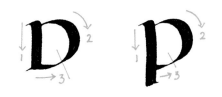

how little information the eye needs to recognize a particular letter.

Other round letters which use the second stroke of O are D and P.

The curve at the top of D springs up from the stem, just as it does with P. D can also be written as:

◆ Make sure that you don't slip back into Foundational mode.

◆ Keep 'thinking fat'.

Letter Groups

The round letters are O C E D P Q G

Begin with the first stroke of O. Put the pen on the paper just below the top guideline, pull round in a half circle and lift the pen when it begins to push up. This stroke also gives you the beginning of several other letters.

As with Foundational hand, put your pen back into the stroke at the top to make a second stroke. Overlap the strokes at the top and at the bottom.

G gives us the first embryonic descender. Keep it really short. It is surprising

I prefer the strength of the version which avoids an ascender.

The straight letters are H I J K L T

Notice that I and J, being capitals, have no dots.

Because the script is solid and chunky, the serifs should match this image. Keep them small and controlled but rounded.

The pen angle has been changed for T and L, and for the crossbar of T the pen angle has been steepened to give it some volume.

The round group of letters.

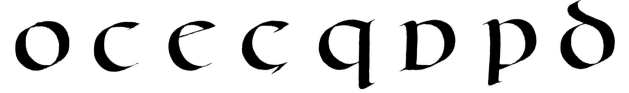

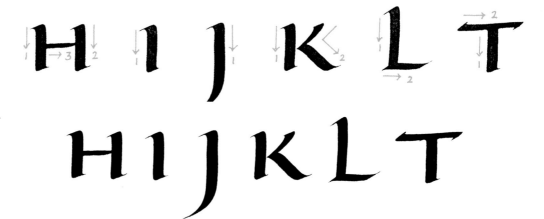

The straight group of letters.

L written at 15 degrees would have a heavy stem but nothing to stand on, so to create a better balance the pen angle has been steepened for the whole letter.

The diagonal letters are N V W X Y Z A

As with all diagonal strokes, the pen angle must be changed as necessary to make the weighting in the letters appear aesthetic and balanced. You will have to experiment, but keep looking at the results with a critical eye.

Keep the width of the letters in harmony with O.

To make A, write the diagonal stroke, put the nib back into the ink and pull it round on the page. You will need to

move quite lightly on the paper. It will come with practice.

The arch letters are M U B R F S

This is not a very satisfactory description for what are really two groups of first cousins.

M and U echo each other in reverse:

Look at the inside white shapes. Make sure that the centre leg of M is straight

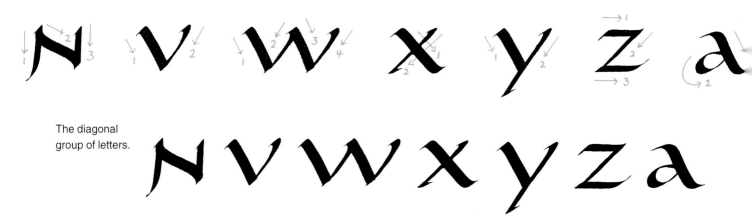

The diagonal group of letters.

and firm. H is sometimes written with an arched bowl.

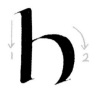

Again, I prefer the contained shape with no ascender.

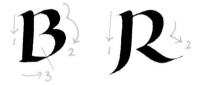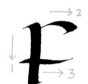

Keep B, R and F wide enough for the inside white shapes to look smoothly rounded. Do not exaggerate the slightly 'kicking' leg on R and F. A longer leg alters the whole balance of the letter and it becomes taller, thinner and weaker.

The arch group of letters.

S is made just like a Foundational S. Keep the horizontal pull on the first stroke to give it width.

HOW TO PRACTISE

Look back at the suggestions for practising Foundational hand. Particular considerations for uncials are:

- Check your pen angle regularly. You will probably revert to 30 degrees without realizing it.

- Do obey the guidelines. This is fat, solid writing which can very easily lose its character if not written carefully.

- Watch the mini ascenders and descenders and keep them really short.

- Keep your serifs neat and controlled.

- Keep the strokes firm and controlled. The temptation to finish, say, the leg of R with a flourish may be considerable – it feels nice – but don't do it.

- Keep thinking fat and round.

- Make sure that your letters do pull horizontally.

- Keep looking at the inside white spaces.

As soon as you can remember enough, write words and sentences. You will find that, because of the pull of the letters and the uniform height, the script creates a very strong ribbon on the page. Try working with smaller nibs. You may also find

that the visual strength can be softened to advantage by writing in colour.

If punctuation marks are essential, keep them small and neat and with the pen angle at 15 degrees.

NUMERALS AND PUNCTUATION

SPACING

1 2 3 4 5 6 7 8 9 0

Numerals

Numerals need to be of a uniform height, as for other majuscules, keeping the 15 degree pen angle, the four nib widths weighting and the round shapes.

These shapes are rather heavy for my taste – they look a bit smug – so I would probably try to avoid using them. Of course, if you don't actually like writing numerals it is always possible to get round this by writing out numbers in words.

Letter Spacing

The letter spacing in the St Cuthbert Gospel is quite close but the writing is very small. At the larger scale at which you are working, you need enough space to create an even pattern along the line. If letters are too close together, uncial writing becomes too heavy and is difficult to read.

The strong ribbon of writing on the page must be allowed to breathe if it is to move pleasantly past the reader's eye.

Punctuation

The St Cuthbert Gospel scribe managed without punctuation marks apart from the occasional initial larger letter, so if you feel that you can manage without too, you are in good company.

Word Spacing

Again, think of the width of O between words, but don't forget that your O is now rather wide. Having got used to quite tight word spacing, you may now find that uncials need a little more space than you thought. The writing can become uncomfortably dense, so keep a careful balance of white space. Allow your uncials to breathe.

UNCIAL WRITINC

9 Expanding the Boundaries

A study of any formal hand based on an historical model will begin with 'rules'. The aim is usually to reproduce the image of the writing and then adapt it for personal and contemporary use. This means analysing the original, picking the bones out of it and inevitably killing the life in it for the sake of examining the structure and the underlying principles of visual aesthetic, touch, movement, materials and purpose which informed the development of the original writing.

When we look at the incised letters of Trajan's Column and adapt them for the pen, we are fully aware that we are going through a number of processes. We look at the original Roman letters, analyse, try to find the essential character and qualities of these images, and then build, by stages, something that is functional for us with that essence at the core. Although the process may not be so long and complicated, this is also what we must do with an historic hand. Today, we don't usually use quills and vellum, speak Latin or use certain mediaeval versions of letters which have become obsolete. These are all adaptations we have to consider when we study a formal calligraphic hand.

BEYOND 'THE RULES'

To enable us to build a useful script, we construct a scaffolding and call it 'the rules'. These 'rules' are very important while we are studying and learning, but what we are really working towards as we struggle with our 'rules' is to put some substance back onto those bones which will have life and character.

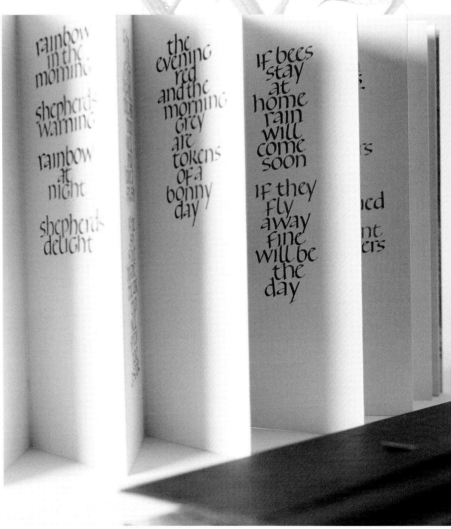

Concertina book.

What does this mean in practical terms? There are different ways of doing it, but I suggest that you consider this approach.

The First Stage

◆ The first stage is to consider the pen angle, the weight and the form of the letters. For this, each script has its own 'rules' which are usually clearly defined and can be expressed simply. This will give an understanding of the letter shapes.

The weight, form and pen angle of italic have been varied to create a range of styles.

The Second Stage

◆ The second stage is to consider the movements by which the letters are constructed and linked as writing. The 'rules' here are more nebulous but should include the order and direction of the pen strokes, the speed with which they are made, the letter spacing and, perhaps, the slope of the writing. This will give the beginning of rhythm, which is what turns a string of letters into writing.

The Third Stage

◆ The third stage is when stages one and two are sufficiently understood, practised and refined for everything to come together to make writing.

At this point, the balance tips and the flow and the visual unity of the writing become the most important qualities. This is when you appreciate that different 'rules' now apply. What began as absolutes to give a structure, a scaffolding within which you could learn and build, have acquired an intriguing flexibility. To learn to write italic, we start with a pen angle of about 40 degrees and letters at five nib widths high, but this is only a beginning. You can change the look of your writing and open up endless possibilities just by altering one of the 'rules'. Write italic at eight nib widths high or three nib widths high, or change your pen angle to 30 degrees or 60 degrees, make your oval fatter, very thin, an oval lying on its side rather than standing up. See what happens, feel what happens to the movement of your hand and arm, evaluate what happens on the page and decide whether it is useful.

Once you have learned to write you will begin to realize that the continuing

'rules' are something like 'Does its appearance please me? Is it right for the context? Does it feel comfortable when I make it?'

When you feel that you have learned a script and no longer need to refer to the letter models, try bending the rules to see what happens. Of course, you may feel that it will take a lifetime to learn the classic formal version and so you prefer to stick with the basic 'rules'. That is a perfectly legitimate response and if it's your decision, then stand by it. However, I encourage my students to bend the rules because, although it is a kind of 'play', a number of important realizations come from it:

◆ A very small adaptation to a script can change its appearance and therefore its character much more than you might realize. Try simply changing the serifs.

◆ Keep two of your basic rules and bend the third, and your writing will look different. Bend two of the basic rules and you may not even be able to remember what classic hand was your starting point. However, many of the variations which you invent will be useful. If you work this way, you will extend your calligraphic vocabulary endlessly.

◆ You do not have to change the letters. Changing the spaces will alter the pattern and the visual image.

◆ If you push one of the classic scripts through stages to an extreme – Foundational hand at one nib width high perhaps? – you will have a better understanding of the similarities and differences between calligraphic hands. Historic scripts don't sit in self-

contained isolated pockets; they evolve and overlap with each other.

◆ By varying the 'rules' you will begin to appreciate why the feeling and look of the basic formal hand works and has become accepted as the 'norm'.

Foundational hand at increasingly heavy weights.

ADAPTING A SCRIPT

Working with your writing in this way will give you a thorough understanding of your basic formal hands. It will tune up your hand and eye and, I think, will help to open your mind to some of the creative possibilities of the craft.

Choose ideas that appeal to you and try them out on any of the scripts that you have learned. Be brave but be selective; look at the results and be thoughtful. A good way to improve your critical appreciation and understanding is to push an idea to the extreme so that you can see where it falls apart and becomes ridiculous. Some of these ideas will produce

a a a g a a a

Varying the serif changes the personality of a hand.

an interesting or useful result with some scripts. Many of the results will be ugly or weak, but you won't know until you've experimented, and, contrary to your expectations, the results may be stunningly wonderful.

To begin, it's probably best not to stray too far from what you know and are comfortable with. For example, you could try varying, or omitting, the serifs on any script with which you are comfortable. Use a large nib so you can see what is happening and then assess how this changes the personality of the letters.

Notice how your movement has to change for a minuscule letter. When you

serendipity

Monoline letters used in a panel of poetry.

have learned the letters of a script, try ruling guidelines 10mm (⅜in) apart and, taking your smallest nib, write between these lines. In effect, you will be writing a skeleton letter which will wobble – never mind – but you will also see whether you've already got to grips with the basic letter shapes.

It is also a good idea to risk writing your formal hand without a top guideline. You may be pleasantly surprised to find that you've learned the look of your letters and no longer need that piece of scaffolding. If, however, your writing dissolves into chaos, you need to continue working to master the basic principles and to reinforce the foundations.

Weight

Begin with capitals and try reducing the x height by one nib width step by step. Look at what happens. If you then adapt and refine your letters and try to make them look good, you will produce some interesting results.

Try this same exercise with other hands. Then try increasing the x height step by step so that the letters become taller and lighter.

Look at what happens when you alter the weight of the writing. In the simplest terms, shorter, heavier writing needs to be rounder so that it has enough space inside it to make it both comfortable on the eye and legible. Heavy, narrow letters are quite tiring to read.

Taller, lighter writing needs to be relatively narrow and compressed so that enough of the space is squeezed out of it to make it comfortable and legible.

Bear in mind that an idea which does not work for more formal writing may work in a different context with a different purpose. Never forget that writing is pattern and different patterns serve different purposes.

And in the frosty season when the sun was set and visible for many a mile
the cottage windows through the twilight blazd
I heeded not the summons: happy time
It was indeed for all of us: to me it was a time of rapture: clear and loud
The village clock tolld six: I wheeld about
Proud and exulting like an untired horse
That cares not for its home – All shod with steel
We hissd along the polishd ice in games Confederate imitative of the chace
And woodland pleasures the resounding horn
The Pack loud bellowing and the hunted hare
So through the darkness and the cold we flew And not a voice was idle.

CAPITALS

'Capitals' written at increasingly heavy weights.

CAPITALS

CAPITALS

CAPITALS

CAPITALS

FANTASY

CAPITALS

FANTASY

CAPITALS

CAPITALS

FANTASY

'Fantasy' written at two, four and six nib widths.

delicate

delicate

delicate

delicate

'Delicate' written at three, five, eight and eleven nib widths.

Changing the space inside and around letters changes the character of the writing.

magician magician

a sleep full of sweet dreams

Uncial writing at two and a half nib widths high is softened by the gentle colours.

Angle

Changing the angle of the pen will probably feel more awkward. It is quite difficult to write an italic branching arch with a very flat pen angle, but try it. Keeping the construction of the letters constant but varying the pen angle will teach you a lot about the reasons behind the basic 'rules'.

rainbow

rainbow

The same pen, held at a very flat and a very steep angle.

Form

If you want to change the underlying form of the script, begin with the O. All other letters must be adapted to keep a harmonious alphabet. This is not necessarily difficult, but it requires concentration. Italic capitals are basically such an adaptation of Roman capitals.

Try adapting Foundational hand – this will prove quite difficult.

Then try it with italic. Because italic is so rhythmic, changing the form is not

difficult. Once you've worked out the new movement the letters will fall into place. This is one of the reasons why italic is such a useful and versatile script. It can be comfortably adapted to create a wide range of distinct hands.

Try a spiky o. Your movement will become staccato, sharp and quick.

How you choose to make the other letters for this hand is your decision. There are many models which are equally valid – there is no 'right' one. You may find it helpful to consider the following points:

- The basic pattern of a spiky italic form is jagged and hard. Work out a movement for your hand.

- Devise a form for a and try relating as many letters as you can.

- Some letters – f and s for example – will give you problems.

- Keep the serifs spiky, thereby maintaining the overall look of the writing.

However, don't use this hand unless you actually want your work to look spiky. Hard, pointed letters can appear very aggressive.

Foundational shapes compressed and then stretched laterally.

diaphanous pellucid

Possible spiky 'o' forms.

dragons in their pleasant palaces

A personal spiky italic hand.

Try making the shapes rounder. Allow your movement to become softer and more flowing. A more languid movement on the paper will encourage the writing to become almost cursive.

Space

The space around letters can be varied deliberately to create different effects. One of the reasons for spending time

mm o move gently

now folds the lily
all her sweetness up

now folds the lily

A more gentle movement produces increasingly fluid and cursive writing.

THE·MAGIC
OF·THE·SEA

LONGFELLOW

The author's name has been spaced widely to create a long line.

sun shine
sun sun
sun sun
SHINING
sun shine
SHINING shining
sun

learning to space letters evenly is that while this gives the most unobtrusive and neutral visual messages, it also means that you have enough understanding to manipulate these messages, to alter the spacing deliberately and in a controlled manner so as to create different textures and patterns in your writing. Probably the most useful results will be with capital forms.

The space inside letters is, of course, equally flexible. If you work on a base guideline alone, or dispense with the guidelines completely and simply doodle, you will produce some odd and quirky images, but again you might light on the germ of an idea which, with refinement, could be useful.

A study of calligraphy begins as a precise discipline. It is a skill which demands manual control, a finely tuned eye and an understanding mind, but it is a skill that is learned to be used. It is not an end in itself. Just like a musician, you must learn to play the right notes, but playing the right notes is not making music. Those 'rules' which you spent so long learning will always be there. They are not to be forgotten, but are there to be used, adapted, interpreted and personalized to suit the purposes of the piece of work on which you are engaged.

10 Colour

Colour is seductive and sooner or later you will want to try using it in your calligraphic work. Writing with colour is no more difficult than writing with black ink; the complications, subtleties and pleasures are all aesthetic.

One of the reasons for working with a dip pen from the beginning is that this enables you to write with paint for your colour work.

Coloured inks, which can also be used in fountain pens, have their place, but generally they are too thin to cover when dry, the colours can't be mixed without producing sludge and, because the inks are thin, they flow rather quickly in a dip pen and are difficult to manage. Some are not lightfast and will fade relatively quickly.

Poster paint comes in strong, bright colours and is inexpensive, but it is primarily a paint for children and is not intended, or suitable, for serious or professional use. Because it is made to be safe enough for a child to swallow it without ill effect, it is bound with starch, and starch cracks and flakes when it is dry.

The technology behind artists' paints and colours has progressed very rapidly in recent years and there is now a wide range of inks, acrylics and emulsions that can be used for writing with excellent results. Some of these need to be diluted with water and when working with acrylics, you must be careful to wash nibs and brushes thoroughly and quickly, but when you have a little experience, it is worth trying some of the different enticing little pots and tubes in your local art shop. However, to begin, and as a general principle, calligraphers write with diluted gouache or watercolour paints.

WATERCOLOUR AND GOUACHE

Watercolour paint is sometimes used by calligraphers and if you already are a painter and have watercolours, by all means use them for your work. Watercolours are pigments prepared to give a translucent effect and are usually more expensive than gouache. Gouache paints are made with the same pigments as are used in watercolours and, for the calligrapher, they have distinct advantages:

◆ Gouache paint is opaque. Inert fillers, usually white or near-white pigments which become clear when ground in oil but which remain white and opaque when mixed with water, are added to watercolour pigments and binding agents. This means that the paint not only covers when you write with it but it has a definite body and sits on the paper.

◆ It is easily available in a very wide range of colours, and is less expensive than watercolour paint.

◆ Because gouache has body it shows up well on coloured backgrounds.

◆ Colours can be mixed as you wish. You can combine gouache and watercolour paints quite happily.

◆ It washes from your brushes and your fingers in water. If you spill it on your clothes, rinse it at once in

cold water and the paint will come out of most fabrics.

BASIC EQUIPMENT

You will need:

- Some plastic or ceramic palettes for mixing paint. A range of dishes will be on sale in your local art shop. Plastic palettes may become stained and discoloured in time, but they are inexpensive, light and easy to stack, so saving space. Ceramic dishes are very pleasant to use and are more stable, but if you have to carry equipment to and from a class, their weight may be a consideration.

- Some brushes for mixing and feeding paint into your nib. Buy several. Inexpensive man-made fibre brushes are best; I like size 4.

- Water pots and paint rags. Jam jars and a redundant linen tea towel are perfect here.

- Some tubes of gouache paint.

Buying Gouache

If you are not used to buying paint, the range of colours available in the art shop may seem overwhelming, but you only need one tube of gouache to learn how to use paint as a writing medium. More understanding of colour can come later.

Essential to any palette are red, blue and yellow and I suggest you begin with a strong red or blue which will show well on white layout paper. Ultramarine or cerulean blue or flame red would be sound choices.

Larger art shops will probably offer two or more different makes of paint. Some makes of gouache flow more satisfactorily in the pen than others – remember that the manufacturers are making for painters, not calligraphers – but how you respond to a particular make of paint is partly a matter of taste and touch and you will only find out by trial and error what suits you best. Generally, it is safer to keep to the well-known makes of paint and to avoid bargain offers.

The various codes on the tube usually refer to the lightfast qualities of that particular paint and to its price. Paints can vary quite significantly in price because different colours are made from different pigments, and some pigments are much more expensive than others. If you can't work out the codes, ask the shop assistant for translations.

A tube of paint will have a long, useful life – maybe several years – before it dries out. Always replace the cap carefully after use and store the paint away from direct heat; that handy little shelf along the top of the radiator is not a good place. In the tropics, calligraphers keep their gouache in the fridge. If you have put your paint away carelessly and the cap now seems glued immovably to the tube, putting the top under very hot water should loosen it. Clean the thread before you replace the cap.

WRITING WITH GOUACHE

Before you open the tube of paint, squeeze it gently a few times. The various components tend to separate out in the tube and you are likely to find your new unsqueezed tube of paint producing a blob of glycerine before any colour appears. Gouache must be diluted with water so that it will flow in the pen. Squeeze a blob of paint, about the size of a large pea, into a mixing dish, add three or four drops of water, preferably with a pipette, and mix together thoroughly. If the diluted paint has a milky consistency, it's probably about right.

Be sure that:

◆ the diluted paint is absolutely smooth;

◆ no lumps of paint are still clinging in the hairs of the mixing brush.

Feed the paint into your nib with the brush exactly as you do with ink, then write. Work with a large nib for your first efforts. If the consistency of the paint is right it will flow smoothly and cover evenly.

Too thick paint will cover imperfectly. Too thin paint will 'puddle' at the base of the stroke.

If your paint is too thick it will flow unevenly and your marks will be ragged. Add another drop of water to the mix, clean your nib and try again. Patience is important. You are working with very small quantities and one drop of water can make all the difference.

If your paint is too thin it may flow very quickly and feel out of control, the marks won't cover but will be transparent on the paper, and the paint will tend to gather in puddles at the base of the strokes, producing high spots of colour. Add a little more paint and mix thoroughly once more.

With experience, you will learn to mix the right consistency more quickly. Usually, you are aiming to thin the paint enough for it to flow evenly but steadily in the nib while keeping it thick enough to cover on the paper.

The colour of the writing is affected by the size of the pen, the nature of the writing (how dense is it? how much space is there inside it and around it?), by the paper and by other neighbouring colours. So you can't know whether that wonderful pool of green which you've just made is going to be right for your piece of work until you've tried it in the pen, using the right nib.

WHEN WORKING WITH GOUACHE:

◆ Try adding the smallest drop of gum arabic to your paint when you mix it. This will help to set the paint on the paper when it has dried and will enable you to remove pencil guidelines if you wish to do so.

◆ There is no need to wash your mixing dishes each day. Let the paint dry out naturally and you can store it, covered against dust, until you next want to use that colour. Then simply add water and remix.

◆ If your colour contains more than one pigment, mix enough to complete the task in hand.

◆ Try mixing your colour, allowing it to dry out overnight before reconstituting it and writing with it. The reactions in the paint when it is diluted and exposed to the air seem to make it flow more easily.

◆ Get into the habit of stirring your dish of paint each time you refill your pen. Some pigments will settle and separate out very quickly.

◆ Keep brushes for colour work and a different brush for black ink. If you are working with several colours, have a brush for each to keep the colours clean.

◆ You will need to wipe or wash your nib quite frequently when using gouache because the paint dries, clogging the nib and hindering the flow.

◆ The paint in your dish will dehydrate as you work, particularly on a warm day. Add a drop of water as it becomes necessary.

◆ Remember that the colour sample on the tube will not quite match the colour inside the tube, which will not look quite like the puddle in your dish, which again will be different from the colour of your writing. Because calligraphers work with lines, the look of your paint on the page will be affected by the size of your nib and the thickness of the line on the page. It can be quite startling to see the apparently different colours of a thick and a thin line, each drawn using exactly the same dish of paint.

COLOUR TERMS

The theory of colour has been explained in scientific and aesthetic terms in many excellent essays and volumes to which you should turn if you are interested in exploring the subject in depth. However, some understanding of the basic terminology is important.

The primary colours are red, blue and yellow. These three colours cannot be made by mixing other colours together.

The secondary colours are orange, green and purple. These are made by mixing two primaries together:

◆ red + yellow = orange

◆ blue + red = purple

◆ blue + yellow = green.

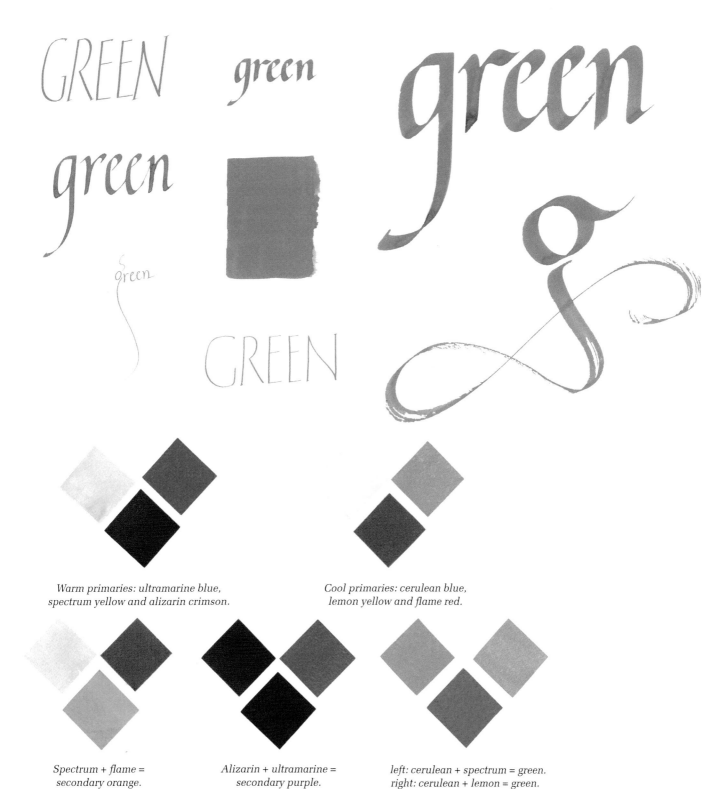

Warm primaries: ultramarine blue,
spectrum yellow and alizarin crimson.

Cool primaries: cerulean blue,
lemon yellow and flame red.

Spectrum + flame =
secondary orange.

Alizarin + ultramarine =
secondary purple.

left: cerulean + spectrum = green.
right: cerulean + lemon = green.
centre: ultramarine + spectrum = green.

The tertiary colours are made by mixing equal quantities of a primary and one of the two secondaries made from that primary.

Ultramarine + spectrum = green, complementary of alizarin.

Cerulean + lemon = green, complementary of flame red.

A colour wheel is the conventional diagram for showing these various colour combinations.

Complementary colours are the two colours, one primary and one secondary, that together encompass all three primaries. So blue (primary) and orange (red + yellow) are complementaries.

◆ A hue is the everyday name for a colour – red, blue, orange, and so on.

◆ A tint is a hue + white to lighten it.

◆ A shade is a hue + black to darken it.

Colours are described as warm or cool. This is a relative, rather than an absolute, term and a colour which appears warm in isolation can become cool against a warmer neighbour. Generally, warm colours are reds, oranges and golden colours with associations of sun and fire, and cool colours are blues and greens with associations of water, ice and winter. Warm colours are usually considered to stand out, to come forwards against others, whereas cool colours appear to recede.

Pigment is usually a powder and is colouring material. It is possible to buy loose pigments and use them to make your own watercolour or gouache paints.

Paint is pigment mixed with a vehicle that will bind and preserve but allow the colour to flow.

As a calligrapher, it is useful to understand the basic terminology, but much of your knowledge is probably going to come from practical experience, from using paint in the pen and observing and evaluating the results. Too often, we refer to books written for painters without appreciating that as calligraphers we are working with dilute colour in a pen and we are making lines rather than a block or mass of colour. This is not to undervalue what can be learned from books about or for painters, but simply to suggest that we should always question, experiment with and explore further the ideas that we gather from such sources and be prepared to adapt and modify them to make them calligraphically useful. In the early stages certainly, these explorations are based on two guiding principles:

◆ Choose a very limited range of paints to work with. This may well be a principle that you will maintain, or revert to, as you become more experienced.

◆ Get into the habit of talking about pigments by name – think of ultramarine rather than dark blue – and learn what each one will do for the calligrapher. Each pigment has its own chemical nature, its own character, and it is important to find out as much as you can about the different habits and behaviour of each of your paints.

So, to put these principles into practice ...

CHOOSING A RANGE OF PAINTS

For a basic palette, you will need the primary colours plus, I suggest, white. Unfortunately, this is where the decisions have to begin. Colour is light, and colour theory is about physics as much as about paints. There is no such thing as a pure primary colour in a tube of gouache. There are plenty of reds, blues and yellows to choose from, but all will have a bias towards one of the other primaries. Ultramarine, which I've already suggested using, is a strong, rich colour, but you can see from its warmth that it has a bias towards red. To create a balanced palette of colours, you need a red-bias blue like ultramarine plus a yellow-bias blue, a cooler blue, such as cerulean. The same is true of red and yellow; for each you will need two paints to give you a reasonable range of possible mixes. Flame red or scarlet lake are both yellow-bias clear reds. Cadmium red is also a beautiful strong colour but it is expensive and can be a bit difficult to handle in the pen because, like all the cadmiums, it is heavy and flows quickly. For blue-bias red, the most useful colour is alizarin crimson, but unfortunately it is not lightfast. One of the more recently developed quinacridone colours might

be a good alternative. Lemon yellow is a good blue-bias yellow and for a warm red-bias yellow I prefer to use spectrum yellow. Again, cadmium yellow is a wonderful strong colour, but again it is expensive and fast-flowing. Permanent white has excellent opacity and is dense and strong, but it will create rather chalky, pastel tints when mixed with other colours. Zinc white, which has a slight blue tinge, will give much clearer, brighter tints.

No white is easy to write with. It will tend to separate out when mixed with other colours, so frequent stirring is essential, and if you want to write in white on a coloured ground, you will find that it takes a bit of practice to handle the paint successfully.

I hope I have made clear that there is no ideal basic palette. Colour is subjective and your choices should first be based on your own taste. Begin with the primary colours that appeal to you and find out what you can do with them.

GETTING TO KNOW YOUR PAINT

Learning about handling and using colour is, from the beginning, an exploration and an adventure. You are finding out what you can do with the paint and how you can use it in your work. Don't think of trying to learn the right way to use it – there is no single right way. There are only different appropriate ways to use paint according to the context of the piece on which you are working. Colour is very personal, as is your work, so the pigments you choose and the ways in which you choose to use them must be right for you and your piece of work.

Perhaps the most important guideline is to keep an open mind, be flexible, be willing to try out ideas and, most of all,

be prepared to make a mess. If you try mixing paints and create a nasty sludge, just wash it away and start again. It is not a mistake; it is a very important part of the learning and exploration process.

If you keep to a limited palette of colours, you will find that over a period of time you will learn a good deal about the nature of each of your chosen paints. You will discover how each paint behaves in the pen, how it combines with other colours, how it appears against a neighbour or a coloured background, and this will lead to an understanding of the visual character and the emotional impact of colours. These are all very important considerations when you are designing a piece of work.

To speed up this learning by experience process, try taking a basic blue or red paint that will show up well on white layout paper and work through the following exercises. If you have a tidy mind, the results could be usefully preserved, with annotations, in a scrapbook.

Experimenting with Paint

Dilute a small quantity of your chosen paint just with water. Notice how soft (or hard) it is, how quickly it dissolves, how easy it is to work with the brush.

Write with the paint using large, medium and small nibs. Does it flow easily in the pen? Is it equally comfortable in very large and very small nibs? Is the writing opaque? Look at the colour of the different sizes of line. Does the colour change as the paint dries? If you rub guidelines away, very gently using a really soft eraser, from around the dry paint, does it lift the colour easily?

Try exactly the same processes, but this time add a tiny drop of gum arabic to your mixture. Does the paint feel any different in the pen? Does it look any different on the page? Are the guidelines easier

to remove? If you want to remove guidelines eventually, it is best to add gum arabic which will help fix the paint to the page. If, however, extra gum changes the handling qualities of the paint, only add it if it is necessary. Remember that each pigment has its own character and its own way of behaving.

Using paint diluted just with water, next try moving onto a good piece of white paper. Write the same word using large, medium and small nibs and be aware of the different feel of the paper. On some good papers, certain sizes of nib will write more comfortably than other sizes, but again this is a personal response depending on your touch. Try as many white or cream papers as you can find. How does the different paper affect the look of your writing?

Try the same exercise using as many different coloured papers as you can find. Here, not only touch will be important but also the look of the colour combinations. You will probably be surprised, even startled, by some of the effects.

This shows that you really can't plan your piece of work in black ink on white layout paper and then decide to do the finished masterpiece in green paint on blue paper. It won't look the same and it probably won't look as you expected it to. It almost certainly will not look right. If you want to work with colour – whether it be coloured writing on white paper, black writing on coloured paper or coloured writing on coloured paper – you must plan in colour.

And you must plan in the right colour; it is no good using up that pot of purple paint while planning your design because there's a lot left over while all the time thinking that you will do the Real Thing in brown.

The same cobalt blue used in number 0 and 4½ nibs on a variety of coloured papers.

AND IN GREEN UNDERWOOD AND COVER
BLOSSOM BY BLOSSOM THE SPRING BEGINS

AND IN GREEN UNDERWOOD AND COVER

BLOSSOM BY BLOSSOM THE SPRING BEGINS

The same text written with the same nib, but one in ink and one in gouache.

Next, try mixing your base pigment to find the range of colours to be made. You will get better results if you move from layout paper to something a little heavier. An inexpensive cartridge paper will be fine. Dilute a small quantity of white paint into a separate dish. With a large pen, make a mark with the pure base colour. Now add a drop of white paint to your colour, mix thoroughly, clean your nib and make a second mark. Add a further drop of white paint, mix, clean

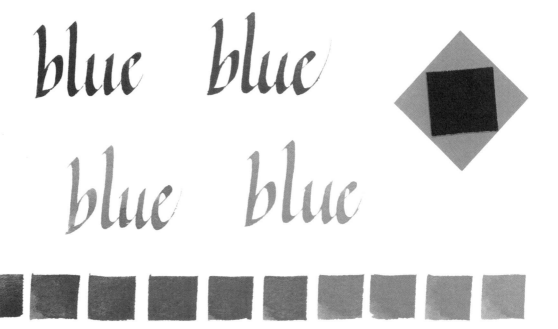

Ultramarine + zinc white.

the nib, make a third mark, and continue in this way until you have made a range of tints. Try writing, again with large, medium and small nibs, with the tints as you proceed.

Repeat this exercise using the same base pigment but this time add one of your other primaries, similarly diluted and drop by drop. Try writing with the range of colours that you produce. Look, but also feel, how the paint mixture changes as you use it in the pen. In theory, if you add enough drops your mixture will almost take on the colour of the second paint that you are adding to your base colour.

Look at the range of hues which you make. How quickly does the base colour lose its character? Which of the pigments appears to dominate? Do the two pigments mix smoothly in the pen? Do they separate out quickly in the mixing dish? Do you like the colours you are making? What happens to them as they dry on the paper? What happens if you add white to the mixes?

If you have two blues and two yellows and you try all possible combinations you will understand why it is not necessary to buy a green pigment. Similarly, mixing reds and blues, you will learn which combinations produce brown and which purple.

Return to your base colour and try writing with it, very dilute, in a large pen. Try writing on textured paper. Try using colour in a split nib or a wedge-shaped brush if you have one. Try using the paint at normal dilution without a reservoir on your nib. The reservoir is there to help and if it is holding the paint back too much, discard it. Try putting two colours into one large nib. Try anything you think of, but look what happens, feel what happens, think about what is happening and, as you probably won't remember, keep a notebook of samples and ideas. Try using your base

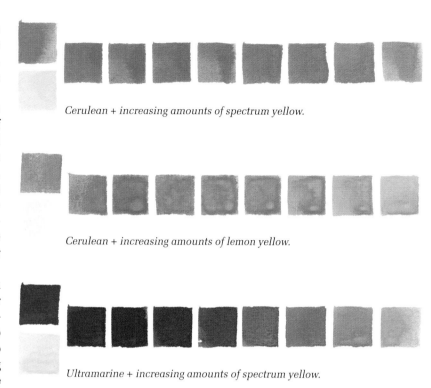

Cerulean + increasing amounts of spectrum yellow.

Cerulean + increasing amounts of lemon yellow.

Ultramarine + increasing amounts of spectrum yellow.

pigment for some of the decorative techniques which follow.

Greater subtleties and new ideas will suggest themselves to you as you become more familiar with the medium. You will discover quite quickly that some colours, if used straight from the tube, are overpowering and too vibrant. Try adding a drop or two from another sympathetic colour; for example, add another blue to ultramarine, or a drop of a blue-red or a drop of white, to take the edge off the pure colour. If you are using two or more colours for a piece of work and want to be sure that they harmonize, add something of one pigment to each of the colour mixes. This common pigment, which may only be a few drops, will create a harmony between the colours that you have mixed.

Keeping brushes, dishes, water and nibs clean as you work is very important. Be demanding of yourself.

The different hues all include spectrum yellow and this common pigment creates a colour harmony.

GOLDEN MEADOW
SUNSHINE EARTH
SUMMER SOIL
SUMMER BRANCH
SUMMER LEAVES
SEASHORE LEAVES
WAVES LEAVES
WAVES LEAVES
WAVES LEAVES
STORM LEAVES

When you feel you know enough to have an opinion, choose the pigments you like and learn them thoroughly. Some pigments are harder to use in the pen than others, but with a little patience you will learn enough of the habits of a favourite colour to use it successfully.

11 Adding Colour in Decoration

There are many ways to enhance a piece of calligraphy with a little decoration. There are also a number of misconceptions about how this is best achieved.

Perhaps the first, and most important, misconception is the idea that a piece of calligraphy needs decoration, that writing without a drawing, a painting, a border or a background is boring and somehow incomplete and inadequate. This is nonsense.

As a calligrapher, you are working with words and with writing, both amazingly subtle, varied and fascinating subjects for exploration, and as you become more experienced you will begin to understand and appreciate the images and visual messages you can create by choosing and adapting your letterforms with care, by selecting the colours in which you write and the way in which you arrange your words on the paper. A thoughtfully chosen text written with skill in an appropriate hand at the right size, using the right colours and arranged beautifully on a good piece of paper is a thoroughly satisfying and aesthetic object, whether you see it as a work of art or of craft. Painting twining ivy up the margins or a row of rabbits across the bottom would not only be superfluous, they would probably be ridiculous. So, if you don't want to add decoration, don't do it.

And if you don't think you can draw or paint, then certainly don't do it! To paint or draw competently takes skill, knowledge and practice, and many a piece of perfectly capable writing has been spoiled by the addition of an incapable painting. Have a respect for your own calligraphic skills, but equally have a respect for the skills of other visual artists. A second misconception is the belief that if you can paint or draw, then you can simply transfer these skills and use them to enhance your calligraphic work. There is some truth in this, although adaptation and compromises will have to be worked out if this marriage is to succeed. It is very difficult to combine realistic painting with writing so that you create a single, unified image. I believe this is because writing is essentially linear, whereas painting usually deals in mass, in blocks of colour. The perspective in a realistic painting may cause conflict with the flat, two-dimensional quality of the calligraphy and the relative scales of the painting and the calligraphy are frequently at odds. Of course, it is perfectly possible to resolve these difficulties and some calligraphers have found masterly solutions, but too often the result looks like a piece of writing with a painting at the side rather than a unified 'object'. By all means combine your painting and your calligraphic skills but remember that you are making a single piece and will need to do some careful thinking. When you do experiment, try out ideas that come to you, however unpromising they may seem, and you may well find your way to some satisfying and pleasing results.

A third misconception is the belief that lots of lovely colour and illustration will compensate for incompetent writing. There may be a germ of truth in this – our first visual response tends to be an emotional response to colour, size, shapes, but this is short-lived. If we look for longer than a minute or so, we begin to notice detail, we begin to read the writing and we begin to evaluate. You can get away with weak writing for a minute or two, no more.

The fourth misconception says 'I can't paint and I'd like to add some decoration to my calligraphy so I'll just add a bit of spatter/sponge on some paint/do a wash'. The word 'just' must be one of the most doom-laden in the English language. There are many simple ways of including decoration in your calligraphic work, but if the technique that you have chosen is to be effective it must be appropriate to, and a necessary part of, the piece of work and it must be carried out with care and understanding. This means thinking and planning and, even with the simplest technique, practising so that you learn how to control the effects. It also means that you are adding something because your work really needs it. Again, it's part of respecting your skills and how you use them.

If this all sounds rather fierce and intimidating, look at it this way. Spatter decoration is one of the simplest and most attractive ways of adding colour. When you try it for the first time you are likely to have one of two results:

Either:

- it will work beautifully first time and achieve just what you wanted. Congratulations – it's your lucky day, and you've learned a new skill. Even if this happens, however, it would be worth spending a few minutes checking what you've done so that you can repeat it. Consistency of paint? Angle of brush? Distance from paper?

or:

- you will produce a series of rather nasty blobs in all the wrong places. But don't give up – try again. Thin the paint, thicken the paint, hold the brush differently, move faster, move slower. After 20 minutes of possibly very messy experimenting, you may well make it work and, because you will have learned to control the effect, it will have become a useful skill.

DECORATIVE COLOUR TECHNIQUES

These are a very few of the simple techniques which calligraphers might choose to use. The possibilities are endless, so therefore:

- Keep an open mind. Be prepared to try anything and when it develops into an ugly mess, put it in the bin and start again.

- Try out your own ideas.

- Try out the following suggestions but don't feel that you must use them at once in a piece of work. Wait for the relevant context to arise.

- Be prepared to give a little time to learning a technique. Usually, if you can't control a technique, it isn't useful.

- Remember that black paint will create some very dramatic images.

The grating roar of pebbles

◆ Remember that the pigment you choose and the paper on which you work will affect the results.

When you have learned a skill, apply it thoughtfully to your work. Some of these techniques are used by watercolour painters and, rather like the realistic paintings, if we want to use them effectively in calligraphic work we should take the idea and then adapt it. We are not painters, we are calligraphers working in a quite different way with different tools. We can borrow the painter's ideas but we must make them our own and appropriate to the work we do.

Useful Materials

For most of these ideas, heavier paper, preferably watercolour paper, will give better results.

Masking tape is necessary for some techniques. This is low-tack adhesive tape which can be removed from paper after use without damaging the surface. Blotting paper will also be useful.

For most of these ideas, working on a flat surface will be more successful.

Spatter

Dip an old toothbrush into a dish of diluted gouache. Hold the brush about 100mm (4in) vertically above your paper and draw the back of a knife blade (I use an old table knife) across the bristles. You can also try flicking the bristles with your thumbnail, although I dislike having dirty fingers. By experimenting with the paint consistency, the angle at which you hold the brush and the speed at which you move the blade you will eventually produce a fine spray.

Stippling

If you want to create the effect of a very controlled spray, you can make it dot by dot either with a tiny nib or a fine brush. It's a therapeutic activity and not as time-consuming as you might think, although it's not for the impatient.

Sponging

Try the different effects to be achieved using natural sponge and the regular

Spatter used through a stencil.

A sponge used gently to produce marks.

Leaf prints.

artificial bathroom variety. Cut your sponge into pieces with scissors, dip a piece into paint and try dabbing it onto the paper. Try wet paint and fairly dry paint, try blotting your sponge before you apply it to the paper, and try adding layers of different colours.

Leaf Prints

Leaves with clearly raised veins will produce the best results. Paint the veined side of the leaf, place it paint down on the paper, put blotting paper over the leaf and press firmly. Continue printing until the paint is exhausted to see what happens to the image. At first you will make blobs, but gradually you will learn to judge the amount of paint that will produce the image you want.

A fresh leaf will take a little while to accept the paint. To hasten the process, wipe the surface with a drop of washing-up liquid.

Leaves are strong shapes and easy to find, but you can try this technique with anything – vegetables, pieces of wood, plants from the garden, fungi. Think flexibly.

Stencils

This is a subject with plenty of possibilities as your stencils can be decoration or letters. A stencil can be cut from any firm card. I like to use acetate bought in a sheet from the art shop. Because acetate is transparent, your image can be traced through it and cut out easily with a sharp craft knife. You can see to position your stencil and the acetate can be washed and reused. The paint can be applied in any way you wish to create the texture you want.

Masking Fluid

Art masking fluid is a solution which flows in the pen or the brush and which, when dry, 'masks' the area of the paper that it covers. The dried fluid and the area round it is then covered with paint or ink, and when all is dry, the masking fluid is rubbed away to reveal the clean paper surface.

To use masking fluid, first shake the bottle vigorously as the fluid tends to separate out as it stands. Decant a little into a mixing dish. Dip your nib into the fluid and write a few letters, being sure to put down a covering layer. You may find it easier to work without a reservoir on your nib. Allow the fluid to dry thoroughly; it will feel tacky to the touch when it is ready. While you wait, wash your nib and/or brush carefully in soapy water. Masking fluid is quite difficult to clean from your writing tools but soap – real soap, not detergent – will usually remove it.

When the fluid is dry, cover it with colour. This could be a wash with paint or ink, sponging, spattering or any other technique you can think of for colouring the ground around your writing. If you use a harder tool such as a coloured pencil, be careful not to move the fluid as you add the top layer. Allow it to dry and then gently rub the masking fluid away with your finger or a soft eraser to reveal the paper. With a little experimentation and trial and error you will think of endless ways of using this technique.

You will get the best results on a heavy watercolour paper, but try it on different surfaces and on coloured papers.

(Left) Paint was stippled with a dry brush through stencils cut in acetate.

The words were written in masking fluid with an Automatic pen on to textured paper and then covered with a watercolour wash.

WHEN USING MASKING FLUID:

◆ Always shake the bottle.

◆ Wash your tools quickly and carefully in soapy water.

◆ Don't expect your bottle of fluid to last forever. It will begin to deteriorate once you've opened it.

◆ Allow your work to dry thoroughly at each stage, otherwise the paint or ink will seep through the fluid and mark the paper.

◆ Don't leave the fluid on the paper for too long or it may discolour the surface.

◆ Don't rub the fluid too energetically, as you might damage the paper.

◆ Write with the fluid on a sloping board to control the flow.

Colour Washes

Laying a colour wash is, in principle, a simple technique. You will need heavy watercolour paper, watercolour paints and a good quality wash brush.

At its simplest, a wash is made by either spreading very dilute paint across anything you can think of BUT – and this is a Calligraphic Health Warning:

◆ You must look at what you are achieving and be honest and critical. Does it look beautiful? A carelessly made wash can be painfully distracting.

GREAT · CLOUD · CONTINENTS · OF · SUNSET · SEAS

'Edited' wash with writing added.

the paper using a broad brush, or by wetting the surface of the paper with clear water before feeding dilute paint into the wet. This is where knowing your pigments becomes very important because you will achieve quite different effects depending on your choice of paint.

Your first efforts will probably be quite horrid, but if the technique interests you, persevere. Try gouache instead of watercolour, or add gouache on top of the watercolour on the paper. Try different pigment mixes, work very large, work small, work wet and very wet. Try

◆ How are you intending to use your wash? If it's a background, is the colour right? Where is your text going to sit? How will the text integrate with the wash to make a whole? Are you making a complete image or is it a piece of coloured paper with some writing on top?

◆ Can you think of more appropriately calligraphic ways of using the technique? It is not inevitably a background. Think of shapes, of masking, of cutting it up.

Laying a colour wash which is attractive and controlled and which enhances your calligraphic design is difficult. If you want to master the technique, look at books on watercolour painting, follow the advice and be prepared to work at it. Again, the potential is enormous, but it needs thought, plenty of practice, and plenty of patience.

Masking Tape

Masking tape can be used to define the edges of an area to be coloured by any of these techniques. Lay parallel strips of tape on your paper and colour the spaces between. Try restricting a wash in this way. When the wash is dry, lift the tape carefully and write in the channels.

Masking tape used to create white channels in a wash.

Salt granules sprinkled on a wash.

Cling film worked on wet paint.

Salt

Sprinkle sea-salt granules over the surface of a half-dry wash and see what happens. When the wash is quite dry, dust off the salt. Try the same thing but using different pigments and sprinkling the salt when the wash is at different stages of drying out.

Cling Film

Drop a piece of cling film onto a still-wet wash and again, see what happens when it dries. Try it again while the paint is still wet, working the cling film with your fingers to control the effects.

Wet into Wet Letters

You will need a large Automatic or Coit pen. These pens do not have detachable nibs but instead have a broad metal edge with which you can make large marks. They come in a range of widths and some have split nibs to give a double line effect. You will also need some very dilute gouache colours and a brush for each colour. Fill your pen with one colour and write a single large letter. Taking a brush, quickly drop another colour into the wet on the page and watch what happens. The surface tension will hold the shape of the letter unless you are very enthusiastic. Now drop in another colour.

Again, this is a technique to try with different pigments. It will work with some combinations but not others.

You must work quickly because your letter needs to be wet in order for this technique to be successful.

a piece of writing by powdering the pastel lightly with a knife and rubbing the powder gently into the paper with tissue or a cloth. You will find by experience how to achieve marks of soft subtlety or denser colour.

Wet into wet letters.

Pastels

If you already work with pastels, you will know how difficult a medium it is to master as a painter. However, using pure pastel or pastel crayon, you can add simple colour 'shadow' to decorate

Pastels can be used to create effects that are very similar to a paint wash, but they can be easier to handle than paint. Do your piece of writing, remove the guidelines and then add the powdered pastel on the top of your piece of work. Although the pastel will dull coloured

those blue remembered hills

Powdered pastel rubbed in lightly with the fingers.

writing very slightly, the difference is usually insignificant and the pastel shading will appear to be behind the writing. This means that you can put the colouring exactly where you want it, and you will not have to struggle to write on top of the pastel.

The soft, powdery nature of pastels means that they can be messy to use – dust everywhere – and they are not stable on the paper and will lift off if touched. It is therefore essential to fix work by spraying it with an art fixative that you will find in your local art shop. Even when sprayed, the pastel will still dust off so it is probably best not to use this technique in a book, or for something which will be handled such as a card.

Pencils

Do not despise the humble pencil. If you always thought 'pencil' meant a blunt HB, try a really soft 8B if you can find one. Try writing with coloured pencils, sharpen a really soft pencil to an edge instead of a point, try a wedge-shaped carpenter's pencil, try watercolour pencils for writing or for decoration. The pencil is a sympathetic tool to handle and can produce a tremendous variety of marks.

Square-Cut Brushes

These are flat brushes that can be handled very much like an edged pen. Choose the firmer man-made fibres. You will probably take some time to get used to the softness and flexibility of the brush, but the correspondingly softer mark can be very pleasant. Find out what the brush will do, how it behaves on different papers, and what mark it makes when almost dry.

Large Pens and Other Nibs

There are many pens and nibs available which are intended to make decorative marks. Try what catches your eye, but be

Letters made with a square-cut brush.

prepared to spend time learning what the tool will do. For example, producing a multi-coloured line with a large pen is a very simple technique, but you will need to find which pigments will behave in this way (most will not), what the consistency of the paint must be and what paper to use. Everything takes time.

String, Balsa Wood, Bits of Twig, Feathers, Blots …

You can write with anything. You can decorate with anything. Try anything you can think of and see what happens. If you can see possibilities in your initial attempts, pursue them. If you can't, drop

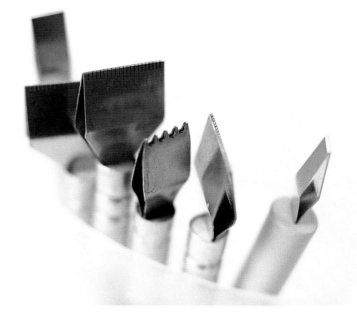

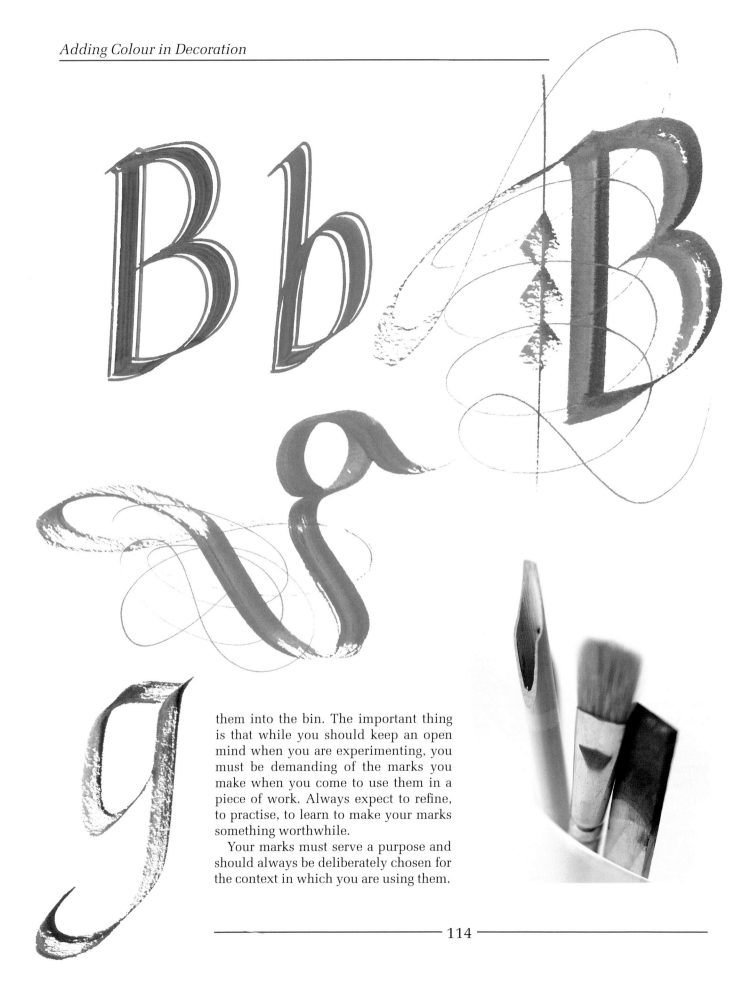

them into the bin. The important thing is that while you should keep an open mind when you are experimenting, you must be demanding of the marks you make when you come to use them in a piece of work. Always expect to refine, to practise, to learn to make your marks something worthwhile.

Your marks must serve a purpose and should always be deliberately chosen for the context in which you are using them.

12 Calligraphic Design

Design is an enormous subject and this can only be a brief introduction. The design and composition considerations which should be applied to a calligraphic work are, of course, specialized; working in a particular medium with particular tools and to a particular purpose limits the number of decisions that have to be made. However, to appreciate what these particular considerations are for calligraphers it might help to think first of the more general.

The results of design are everywhere. In the most simplistic terms, if it didn't grow, it was designed. It possibly wasn't designed with much thought or skill, and if it was intended to be useful the aesthetics may not even have been considered, but someone designed it.

We all design all the time, whether we are reorganizing the sitting room furniture, planning the garden or simply arranging food on a plate. Because the results of design are everywhere, our concern as artists and craftsmen is for good design and to understand, recognize and appreciate what that means.

For the calligrapher, it might be helpful to begin by thinking about two very general principles.

The first is that calligraphy is a visual art. Your skill in organizing a piece of writing on paper will be enhanced if you deepen your appreciation and understanding of the visual arts in general. This is a grand way of saying that going to see an exhibition of paintings, ceramics or Roman coins is all part of learning to be a calligrapher, of learning to see. You may know nothing at all about bowls and pots and jugs, but you can learn a lot by looking at the shapes, at the colours, at the textures on the surfaces, at the decoration that has been used, at the purposes they were intended to serve, and at the arrangement in the display case. Try to look thoughtfully. If you respond quickly with love or loathing, try to work out why you feel as you do. Which object in the exhibition do you find the most appealing? Which would you like to take home? Analyse your choice. Take the game seriously and really think about it because only by thinking will you develop your seeing eye. Next time you go to the theatre, look at the set, look at the patterns in which the director arranged the actors on stage. It's just as much a composition as is a painting.

And listen to the words carefully. The second principle to remember is that calligraphy is about writing. Writing is the visual expression of language, so it is concerned with letters but also with words, ideas, thoughts, feelings, verbal communication. You will need plenty of words to write and you will enjoy your writing much more if the words mean something to you. Keep a notebook or a folder of ideas and jot down any pieces that catch your ear. It may be a great poem or an extract from a novel, a cutting from a magazine or something overheard in the supermarket queue. It might

be profound or it might simply be a neat turn of phrase or a striking image or something which made you laugh. Just as looking at pots will help to sharpen your eye, so reading and listening will help to tune up your sensitivity to language, adding another layer of appreciation and enjoyment to your calligraphy.

All this understanding and awareness will only come with time, but experience will feed your appreciation and your critical judgement, and the continuing process will be both enjoyable and rewarding.

Before embarking on the more practical aspects of calligraphic design, there is in fact a third principle to consider that is just as important to the poet, the painter or the landscape gardener as it is to the calligrapher – that composition and design are hard work.

The calligrapher who tells you that he or she just sat down and produced an original piece of work without any effort either has the benefit of thirty years' experience (and is probably bending the truth) or is working to a formula, maybe without realizing it, or is simply lying. There are times when repeating a design idea is appropriate, when another poster or another birthday card is needed, when time is short, or when you've resolved a design idea that you like and want to make again. This will take relatively little time and effort and it's fine to work that way, but a fresh and original design, worked through from the beginning to a satisfactory conclusion will always involve effort. You will do a lot of writing and a lot of thinking and it may take a considerable amount of time. Sometimes the ideas will flow quickly and your work will develop rapidly and with apparent ease; at other times you will feel that it is a struggle. However, the satisfaction of producing a rounded and complete piece of work will be real and worthwhile, and enormously pleasurable.

STATING THE OBVIOUS

The trouble with the obvious is that sometimes it is so familiar that we don't even realize it's there. The following statements should always be at the back of your mind when you are designing a calligraphic piece, but not so far back that they get forgotten.

1. We can all write and we have certain preconceptions about how writing is presented.

Try this; take a pencil and paper and, using everyday handwriting, write the alphabet in capital letters. Now write it in minuscules. When I've done this exercise with classes, almost everyone: writes from A to Z in sequence; begins writing in the top left-hand corner of the paper; writes in more or less straight lines; and makes the capital letters larger than the minuscules.

Why do we do this? Because we are conditioned, from the time when we first experienced writing, to accept this as the standard. For calligraphers, the rules are different, and we can bend and interpret them as we wish, but we must be aware that people looking at a piece of our work are conditioned as we were. They will look to read from the top left-hand corner, they will expect capitals to be more important, and they will expect the alphabet to begin at A, unless we give the necessary visual information to tell them otherwise. It is perfectly possible for your text to begin in the middle of the page and then move round in every direction, but your design must make it clear to the viewer that this is your intention. The design must override the conditioning.

2. Calligraphy is not the same as painting.

Calligraphy is different; it is created for

different reasons and needs different skills and different ways of thinking. You don't need a conventional art training to be a calligrapher. If you are a painter, or another kind of visual artist, you will have technical skills and knowledge which can be employed in your calligraphic work, but they must be adapted and made relevant. Many painting books will give you useful insights into design, but read them with a questioning mind and be prepared to modify and amend ideas.

3. Calligraphy is line.

Calligraphic works may include any images made in any way that the artist feels to be relevant, but pure writing is linear. In some ways, it is close to the poetic or the musical line. A line of writing is made continuously with a beginning and an end and is best made when the flow is uninterrupted. The mark is made directly and cleanly. Just as a musical note is sounded and exists, so a written mark is there when your pen touches the paper. This immediacy means that writing is a high-risk occupation – making your finished design is a performance – but the directness gives the mark energy and vitality.

4. It does not exist until you have written it.

It may simply be an abstract idea that is still in your head or a piece of text on a printed page that has no calligraphic life. You cannot begin to make a calligraphic design until you have got some calligraphy to design with, so write it out. You will probably change everything as your design develops and you will do a lot of writing, but you will only know if that wonderful idea in your head really does look good when you can actually see it.

WHERE TO BEGIN

When making a calligraphic design there are many elements to consider, but the decisions you make must be determined by the particular piece of work, by what you want it to say and do. As usual, the real rules are much more general than you might be hoping for. And think of it this way: if there were precise, easy-to-follow rules, while these would eliminate much of the struggle involved in resolving a design, the inevitable result would be bland, formulaeic work that looked much like everyone else's. Most people would like to be creative and imaginative, but creativity is hard work and demands thought, self-reliance and concern for a few general principles rather than for lists of detailed rules. So, what follows are simply my suggestions of elements to think about as you design. With more experience you will find out your own ways of approaching a piece of work. The decisions will be yours and based upon what you feel your piece of work needs.

The Idea

To begin, you need the germ of an idea. This might be very simple, such as wanting to practise uncials, or practical, such as making a birthday card, or more complex and subtle, such as writing a poem that has impressed or moved you. Whatever your initial idea, ask yourself:

- Why do I want to make it?

- What do I intend to do with it when it's finished? (A poem written out because you love it but will then put away in a drawer is not necessarily the same as a poem framed and hanging in the dining room.)

◆ Are there any externally imposed limitations? (If it's a card, does it have to go in an envelope, must it be finished by Friday, does the recipient hate green?)

As your skill and ambitions increase, you will inevitably find yourself struggling with troublesome design ideas and it is often useful to come back to these all-embracing principles. Keep asking yourself 'What am I trying to make and for what purpose?'

If the text is not part of your initial idea, such as a poem or the wording for an invitation, the second step is to decide what words you are going to write.

The third step is to write them. Take a pen and a script with which you are comfortable and write your text. You now have something real and of your own making with which to work.

What Script?

This is usually the most difficult and most important design decision, so it becomes my first consideration. As you have already discovered, all writing has personality and the viewer will respond to this character before he or she looks closely enough to read the words. Consider what you know about writing and select the most visually appropriate hand. Try a few minor amendments to make the picture more precisely what you want. You may feel that italic is right for the poem you want to write so begin with the classic formal version of italic and look at the image you are making.

formal

formal

Would it suit the poem better if the writing were a little lighter and more delicate? Try rewriting with the same nib, but increase the number of nib widths for the letter height. Or maybe it needs to be a little more solid; try writing with a letter height of fewer nib widths. Maybe it needs to be more formal or more informal. Try a different serif or stretch the spacing a little or make it look a little more cursive. Be prepared to doodle and to try

quiet **strong**

FRAGILE

anything that comes into your head. Most of what you try will be useless for the piece of work in hand, but it is all going to fill up the pot of your experience which is where your future ideas come from.

If the text demands a formal presentation the decisions are probably easier. Poetry needs more deliberation because you are making a visual interpretation of your personal thoughts and feelings

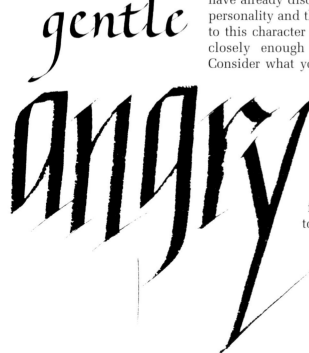

gentle

GRAND

friendly FRIENDLY

Which hand has the right personality for a Christmas card? These free capitals were developed after a good deal of experimentation. The card, a long thin lateral shape, was folded in the middle and the writing went along the back and round onto the front.

MAKE WE MERRIE

Make we merrie

Make we merrie

MAKE WE MERRIE

MAKE WE MERRIE

MAKE WE MERRIE

about the poem, so you may need to doodle for longer. Take what you know and bend the rules just a little.

What Colour?

Sometimes you know at once what colour a piece of work needs to be. The person who asked you to do it wants brown, or that quotation just has to be blue. But at other times you must work your way to a decision. What colours do the words suggest? Think of the purpose of what you are making and the image you want to create. What do you like? Remember:

◆ that many colours have symbolic significance;

◆ that there are conventions about some colours, such as red and green for Christmas, blue for boys, red for hearts and passion, which you can use or ignore as you wish;

◆ that colour provokes an emotional response; the viewer will respond to the colour before he or she reads the words, so your colour choice must be appropriate;

MAKE WE MERRIE

clear
moon
frost
soon

rainbow
in the
morning
shepherds
warning

rainbow
in the
morning

shepherds'
warning

rain rain
go to
spain
come again
another
day

clear
moon
frost
soon

- that we all have favourite colours and you may, without realizing it, get stuck in a colour rut;

- that black is almost always acceptable, so don't feel that you must use colour;

- if the finished piece is to be in colour, work with colour from the beginning. Modify or change the colour as necessary as your work develops.

If bees
stay
at
home
rain
will
come
soon

If they
fly
away
fine
will be
the
day

What Scale?

This decision will often be made for you. Before designing your Christmas card or an invitation, check envelope sizes. Beautifully written labels must sit well on the wine bottle/jam jar/cupboard door/folder that they identify. Even work to hang on the wall has certain limits. I remember a friend who commissioned a piece of calligraphy being dismayed when the first draft, five metres long, arrived for his consideration. After discussion, the artist did rethink the piece to make it cottage-wall size. However, working within more conventional boundaries, you must decide the overall size of your piece and then the scale of your writing. The writing comes first.

THE SCALE OF WRITING

This is all part of the personality of the letterforms that you have chosen and you must think about the needs of your text before choosing a size. Try writing the same word in the same hand with your largest and smallest nib and you will see the point.

You may have to try several possible solutions, but decisions will come the faster with experience. Consider the following points:

- Have you chosen to write at a particular size because you find it easy? If you always use a number two nib because you like it, all your work will look the same.

The hand for a small book eventually developed from Foundational into something much freer but still with a round solidity which I felt was appropriate to the text.

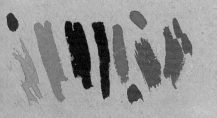

rainbow
in the
morning
shepherds
warning

rainbow
at night
shepherds
delight

rainbow
at night
shepher
delight

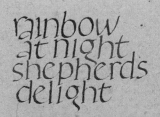

heat and sun

heat and sun

heat and sun

heat and sun

heat and sun

heat and sun

heat and sun

None of these colours is intrinsically either right or wrong for the words, although we might expect heat and sun to be warm reds and oranges. Your choice should be deliberate, relevant to the text and made with an awareness of the emotional response that it will provoke in the viewer.

You will only learn to use a small nib skilfully if you practise.

◆ Think about the words. Do they need to look imposing or intimate, eye-catching or subtle, noisy or quiet? Look at the script, the colour and the scale you've chosen and try to imagine what the words now sound like as you've written them.

◆ Think of the purpose of your piece. If it is to hang on a wall, will the image you've made pro-voke the reaction you want? Does it look important enough, friendly enough, calm or lively enough for your purposes?

◆ Writing is different from print. Are your decisions about the scale of your writing being inhibited by what you are used to in print?

YOU
ARE
THE
SUN
SHINE
OF
MY
LIFE

This piece needed enough variety of colour to create a sense of lightheartedness without introducing so many colours that it fell apart. Notice that the blue letters, which stand out, make a pattern in themselves.

Large strong writing

LARGE STRONG WRITING

◆ Are you being influenced by your everyday handwriting and allowing your hand to revert to what is familiar?

Serendipity
serendipity
SERENDIPITY

THE SCALE OF THE WORK

Sometimes you know a poem needs to be tiny or a card needs to be large, but often a piece of work grows during the making. Always use paper which is too large so that you have a sense of making a composition. Work away from the edges so that there is space around your writing. You will begin to see your work as a picture rather than as lines of writing on paper, and that will give you a sense of where the edge of your 'picture' needs to be.

Because calligraphy is linear, it contains a lot of white space – space inside the letters, space around the letters and between the lines of writing – so it needs clear space around it if the writing is to hold together as a shape.

Conventionally, a piece of work has more empty margin at the bottom than at the top. To determine where the edge of your finished piece of work should be, cut four long strips of dark coloured paper, lay your piece of work on a flat surface and place the four strips around the writing like a picture frame. Try moving the strips closer to the writing or further away; move the bottom strip and/or the top strip; move one or both of the side strips. Look at what each different framing does to your work. Look at the shape your work makes on the paper

It is a beauteous evening calm and free

Decisions about the style of writing, size and colour have all grown out of the words.

the sounding cataract haunted me

and look at the channel of space around it.

Mark the edges of your 'picture' with a pencil and cut off the surplus paper.

What Shape?

Because we are so used to thinking of writing as lines, we tend to forget that a block of lines of writing has a shape. Print is usually organized in fairly uniform blocks of straight lines with a straight left edge and possibly a straight right edge too. Calligraphy has the freedom to range at will, but lines of writing still need to sit as a shape on the paper.

For your first pieces, you may wish to keep the left-hand edge straight. The right edge will be ragged, but by breaking your text at different points you will be able to create an attractive pattern. Try laying your margin strip near to the right edge so that the shape is clear.

Next, try arranging lines of different lengths either symmetrically or asymmetrically. A symmetrical design will always look calm and balanced while an asymmetrical pattern has more tension but still has order. When you have written the lines of text, take a sheet of layout paper, lay it over your work and with a pencil draw round the outside edge of your text block. Then look at the pencil shape you have drawn. Does it look attractive and balanced? Are there long bits sticking out or too many indentations? Does the edge become too straight and solid at any point? Look at the shape upside down and sideways. This will help you to see which lines of writing need to be moved to make a better picture.

However complex and complicated your work becomes with time and experience, this principle is still important. If you are putting several different texts together into one piece of work, each written element must have a considered

Too tight a frame means that the work has not got room to breathe and you, the viewer, can't see the shape of the piece of writing *(top)*. Too much margin and the writing floats in space and looks insignificant *(middle)*. A comfortable margin means that you can see the shape of the text block and the space around it is all part of the piece you are making *(bottom)*.

shape and those shapes must be visually related and linked.

What Spaces?

Letters are about marks and spaces, writing is about letters linked by spaces, and calligraphic design is, essentially, about writing joined by spaces. Space is very important and is just as important in a design as are the marks.

Varying the spaces inside and around the letters and words is a way to alter the texture and character of your writing. The visual impact of your writing will also be affected by what spaces you choose to leave between the lines of writing.

For a formal piece of work, where legibility is of prime importance, the line spacing has to allow for easy eye travel along the line. Begin by making the line spacing uniform throughout the text block and the line spacing equal to the body height of the letters multiplied by one and a half. Look at the texture this creates. You will need to adjust these measurements, maybe a little or maybe a lot, to achieve the look you want but you will quickly realize that, in general:

- Shorter lines of writing need less interlinear space to keep the eye moving, whereas longer lines need more space.

- Some hands need more interlinear space than others to accommodate ascenders and descenders.

1. The dragon-green
the luminous the dark
the serpent-haunted sea

2. The dragon-green
the luminous the dark
the serpent-haunted sea

3. The dragon-green
the luminous the dark
the serpent-haunted sea

4. The dragon-green the luminous
the dark the serpent-haunted sea

The first version (1.) is too tightly spaced, the second (2.) too open. The third (3.) is the most comfortable. When the line length was changed for the fourth version (4.), the interlinear space was also increased a little to create a similarly comfortable texture.

The third italic version (7.) has an interlinear space of a little more than 2x. The same layout in Foundational (4.) has an interlinear space of a little less than 2x.

5. The dragon green the luminous

the dark the serpent-haunted sea

6. The dragon green the luminous
the dark the serpent-haunted sea

7. The dragon green the luminous
the dark the serpent-haunted sea

◆ Capitals are perfectly legible with very little interlinear space.

◆ Wide line spacing inside a piece of work means that wide margins are necessary if the piece is to hold together as a shape.

With a little experience you will begin to appreciate the visual importance of the spaces between the lines. By experimenting with different line spacings you will begin to create attractive textural patterns. You will see that varied spacing can encourage the viewer to read at different speeds, to pause for breath, to linger over one idea and to hurry over others. But always remember that your design is a pattern and that patterns need a little variety to make them interesting, although not so much that they dissolve into chaos.

THE DRAGON-GREEN
THE LUMINOUS THE DARK
THE SERPENT-HAUNTED SEA

THE DRAGON-GREEN

THE LUMINOUS THE DARK

THE SERPENT-HAUNTED SEA

Space related to calligraphic design is an enormous subject. You need to be aware of it because it is often the spaces, or the lack of them, which cause the design problems. Always be aware of:

- *The spaces inside the writing.* Is the texture right? Is the writing too dense or too open for your purposes? The most common fault is letters that are too close together and words that are too far apart, creating a 'hiccuping' reading pattern.

- *The spaces between the lines.* Again, is the texture creating the right image, achieving the purpose you intended? Is the text as legible as you want it to be? The lines must be close enough to look as though they belong to each other but far enough apart to be comfortably read.

THE
DRAGON GREEN
THE LUMINOUS
THE DARK
THE SERPENT
HAUNTED
SEA

And colour changes it again.

- *The spaces between different areas of text.* Do the texts look as though they belong to each other, to the same piece of work, while keeping separate identities? Too much space between different elements becomes a hole.

◆ *The space around your work.* Are the margins large enough to frame your work?

Learn to look at, to understand and to love space; it is important.

What Materials?

At an early stage in your design planning, you should consider what tools and materials you are going to use to make your piece of work.

What you choose to write with will inevitably resolve itself as you work. If you are working with steel nibs, it is sensible to put the particular nib used for a particular project on one side. Not all number three nibs are exactly the same and for a formal piece of work that demands exactly ruled guidelines you can find yourself with problems if you change nibs mid-project. When you are ready to write the Real Thing, don't treat yourself to a new nib but keep to the one you've used for rehearsals.

More significant perhaps is deciding what type of paper you are going to use. All your effort and hard work deserve the best presentation so use good quality paper. Think about the paper early on in your design. The paper is part of the object you are making and you need to use it, to get to know it, to practise on it, to see how your ideas look on it. Practising on good paper isn't wasting paper, it's learning paper.

When you have finished your piece, think about how to present it. Does it need to be framed? Does it need to be protected when stored? If it is small – a card or a small book, for example – wrap it carefully and carry it in an envelope. Treat your work with respect; it deserves it.

MOVING ON

All these elements will continue to be considerations however experienced and skilled you become. In time you will learn to handle more subtle and complex ideas, but making a calligraphic design will always be demanding. Just consider:

◆ You will continue to worry that your writing needs to be better, that a piece is not right and has not lived up to your hopes. This is normal.

◆ Do not expect too much to happen too quickly. Begin with 'simple' designs and learn to refine the details. Get the line spacing, the shape and the margins as correct as you can. This will give you the critical skills to handle more complicated projects with success.

◆ It will all go horribly wrong. If you do not make mistakes, you will not make anything worth making. Mistakes are part of stretching yourself, being creative, taking risks.

◆ Technique is learned to be used. Stop practising letters and do some writing; make something.

◆ You should enjoy the making and find satisfaction in the results. Your work is you, even if you try to hide by copying someone else. The more you care about what you make, the better your work will be.

Clarify in your mind what you are intending to make. Hold on to that vision. Allow your ideas to develop as you work. Move one step at a time. Certain decisions will inevitably lead to the next step and in time little bells of recognition will ring in your head. With practice you will learn to listen to them.

Useful Addresses

SOCIETIES

Two societies based in London have an international membership:

The Calligraphy and Lettering Arts Society
Secretary: Sue Cavendish
54 Boileau Road
London SW13 9BL
0181 741 7886

(Magazine: *The Edge*)

The Society of Scribes and Illuminators
The Art Workers Guild
6 Queen Square
London WC1N 3AR

(Magazine: *The Scribe*)

There are societies and active calligraphy communities throughout the world, particularly in the USA and Canada, in Australia and New Zealand, in South Africa and in Europe.

MAGAZINES

Letter Arts Review
1624 24th Avenue SW
Norman OK 73072
USA

This magazine is available internationally.

Most societies, however small, produce a magazine or newsletter.

SUPPLIERS

Atlantis
7–9 Plumbers Row
London E1 1EQ

(*Art materials and papers*)

Cornelissen
105 Great Russell Street
London WC1B 3RY

(*Artists' colourmen; art supplies and gold leaf*)

Falkiner Fine Papers
76 Southampton Row
London WC1B 4AR

(*Specialists in fine quality papers*)

Paperchase
216 Tottenham Court Road
London W1

(*Art materials; interesting and unusual papers*)

William Cowley
97 Caldecote Street
Newport Pagnell
Buckinghamshire

(*Vellum manufacturers*)

John Neal, Bookseller
1833 Spring Garden Street
Greensboro NC 27403
USA

(*An extensive catalogue of publications by mail order*)

WHERE TO LEARN

West Dean College
West Dean
Chichester
West Sussex PO18 0QZ

West Dean College is a residential arts and craft college that holds short courses in calligraphy.

Department of Art
Froebel College
Roehampton Institute London
Roehampton Lane
London SW15 5PJ
0181 392 3653

The calligraphy department at Roehampton Institute has a wide-ranging programme for all levels of expertise, including beginners, which includes the probably unique three-year BA in Calligraphy courses.

Index